AT HOME

PHOTOGRAPHS BY NORMAN SANDERS

MORGAN & MORGAN

1977

Morgan & Morgan, Inc., Publishers
145 Palisade Street, Dobbs Ferry, New York 10522
Printed in the United States of America

International Standard Book No. 0-87100-137-3
Library of Congress Catalog Card No. 77-83835

Cover and Book Design: Hoi Ling Chu

THE PEOPLE WHO PARTICIPATED IN
THIS PHOTOGRAPHIC PROJECT
APPROACHED IT WITH A SPECIAL
KIND OF GENEROSITY.
THE BOOK IS DEDICATED TO THEM
WITH MY GRATITUDE.

For a long time I have been fascinated by the relationship between people and the settings they create to live in. Some houses are furnished by design and some by accumulation; but either way, the home is a statement of priorities and of attitudes toward possessions, status, comfort and beauty.

It occurred to me that in the setting where a person feels most secure, it might be possible to capture on film something of the inner life of a sitter. So, in 1974, I began photographing people in their favorite rooms at home.

The subjects were, for the most part, strangers to me—people suggested by friends, by others who had heard about the project, or by those I had already photographed.

Aside from limiting the locale to Rockland County, I kept the work free of contrivance. I never looked for any particular kind of person, never sought to influence the choice of clothing, of position or of posture, never tried to fit anyone into any kind of master design.

Since a photographic lighting device can alter the character of a room, none was used. Instead, each photograph was taken in the light normally present. The increased exposure time necessary in this natural light resulted, occasionally, in blurring.

More often, it imparted a sense of special stillness—a quality that made the image seem suspended in time. I made no effort to overcome this effect and feel it is appropriate to the concept of the project.

There is always a temptation, when publishing a collection of photographs, to add commentary to the images in order to clarify or enhance the visual impression. I believe such a text would limit rather than liberate the meaning of this collection, and would violate the spirit of the work.

From the start, I perceived that the people who agreed to sit for these photographs were entrusting me with deep and often delicate feelings. What they open-heartedly offered to my camera could easily be distorted by words, so it must be left to the viewer to sense the moods and interpret the symbols that evoke his understanding.

Each subject brought a unique quality to the project, a personal and intimate way of relating to the camera. Taken together, they convey the message in the work.

Norman Sanders,1977

INTRODUCTION

In these photographs of people in their favorite rooms at home, Norman Sanders celebrates the individuality of the individual. He has succeeded in the difficult task of making strangers interesting.

He has accomplished this with a minimum of prompting or direction, encouraging his randomly chosen subjects to dress and place themselves, naturally and comfortably. Each photograph was made with the light available, using long exposures, thus creating both depth of field and an impression of timelessness.

It is a tribute to the excellence of these photographs that they do not require words to make their message apparent. Each picture tells a story. Surrounded by their own symbols of comfort and security, these people posed themselves in their secret rooms, their facial expressions and body language revealing their unique personalities.

Obviously, the photographer is not an Olympian observer protected by the lens; his presence is recognized and accepted. So sympathetic is his rapport with his subjects that we seem to be invited to a very personal and private glimpse of their lives. The more you look, the more you see. The significant details are eloquent. Note the reflection in a mirror, the knife in a target, the pictures on the walls, a clock, a mask, a musical instrument. Look at the expressive postures and the choice of clothing. Observe the frequent preference for bare feet.

Norman Sanders is a classical photographer working in the current documentary idiom, and his style embraces elements of both the past and the present. It was Julia Margaret Cameron who first made revealing portraits of her acquaintances. It was Eugene Atget who presented their environment in minute detail.

In the beginning, those who used the camera tried to make photographs that looked like paintings. As pictorialists, they made bromoils, montages and manipulations that were considered artistic expressions. With the Photo-Secession, Alfred Stieglitz brought this approach to an abrupt end.

Photography is now recognized as a visual medium with its own unique characteristics—controlled perspective, full gradation of tone, stopped action and sharpness of image. These inherent qualities acquire a cumulative effect in the documentary photograph. In order to distinguish this type of photograph from the routine record, two important elements must prevail. First; the photographer should observe the scene with sensitive perception, carefully interpreting and recording that which is significant. Second; the honesty and credibility of the image should be enhanced by all the techniques required for quality—superb craftsmanship, lighting and composition.

Thus, the documentary photograph in its best form accomplishes what is implied in the word document. Derived from the latin *docere*, meaning to teach, a document teaches, informs, instructs. In this sense *At Home* is a series of documentary photographs. With it, Norman Sanders, is teaching us something elusive and valuable about people and their environments.

There is humor and understanding, but no condescension in these images which have even greater impact because the photographer's technique is restrained without any mechanical intrusion. His photographs may answer some questions about his subjects, but they also raise other questions that are not easily answered. Because the truth has many interpretations, the response to these pictures will vary with the viewer.

This collection of photographs by Norman Sanders of people in their quiet, undisturbed environment reveals more of the human condition than the fleeting observations of the moment. They are commendable for their lack of pretense, their superb technique and their subtle perception. Through these images in the documentary tradition, we discover in the lives of ordinary folk, rare and unique human qualities.

Arthur Rothstein

PLATES

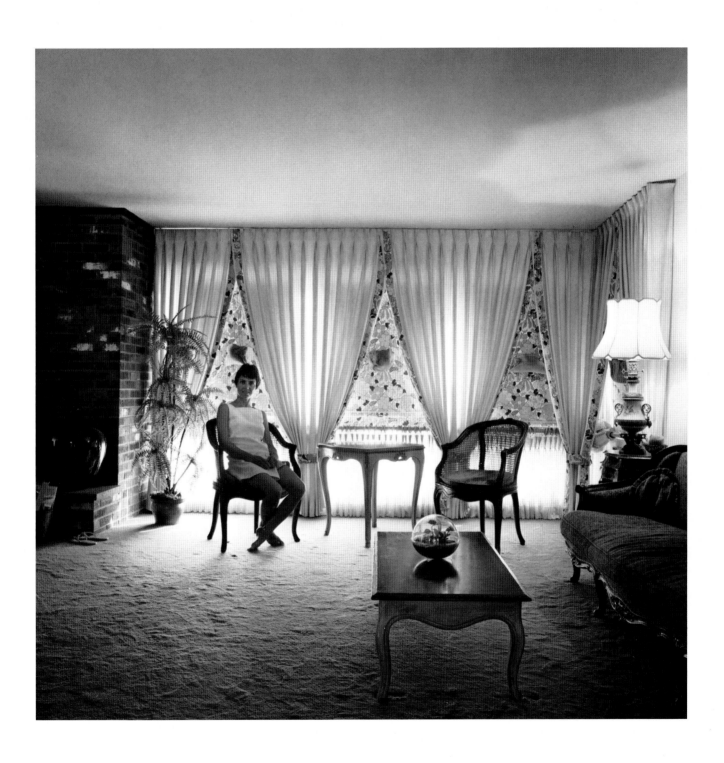

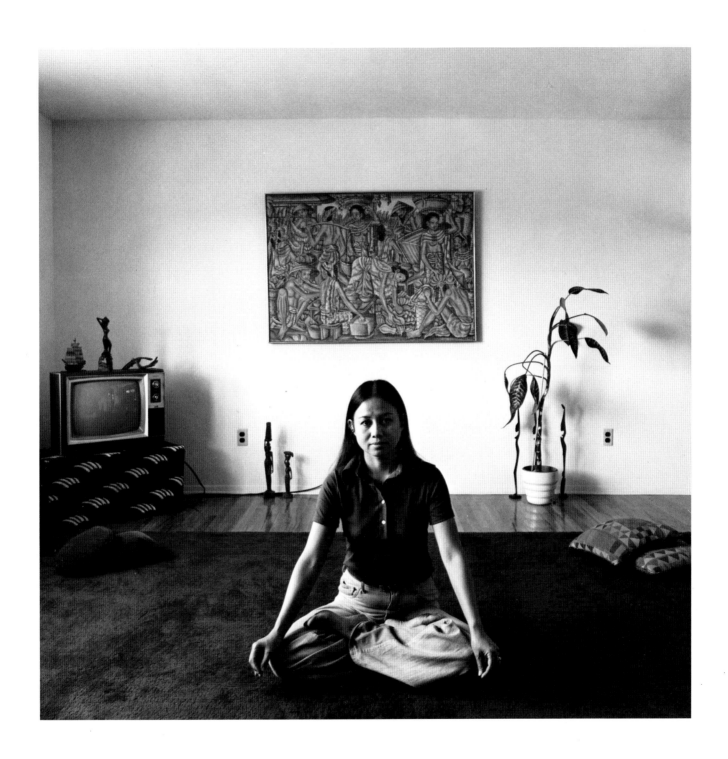

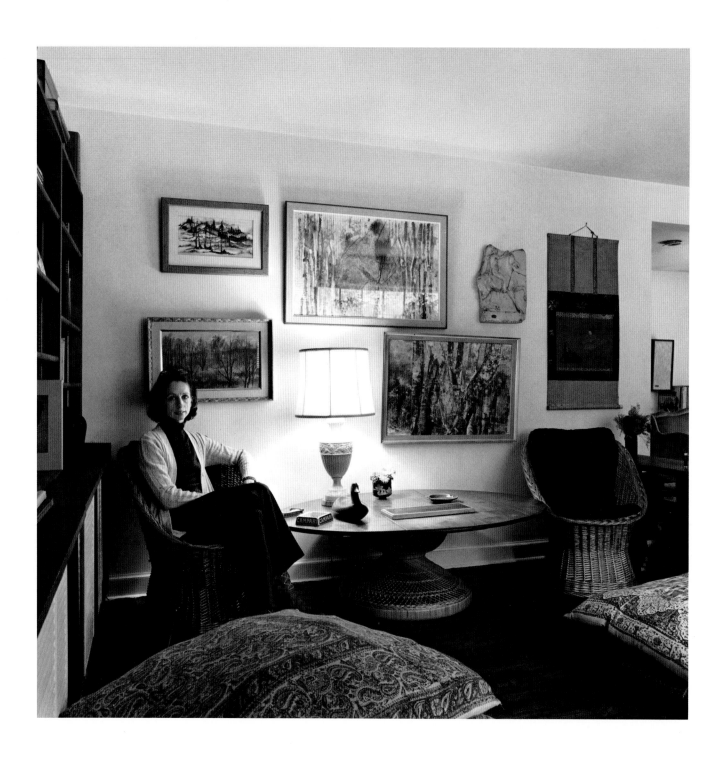

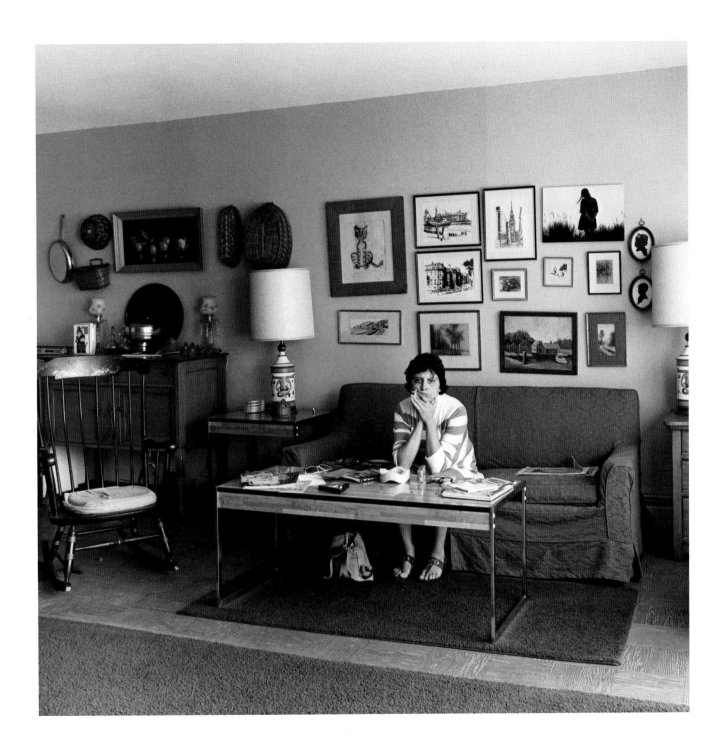

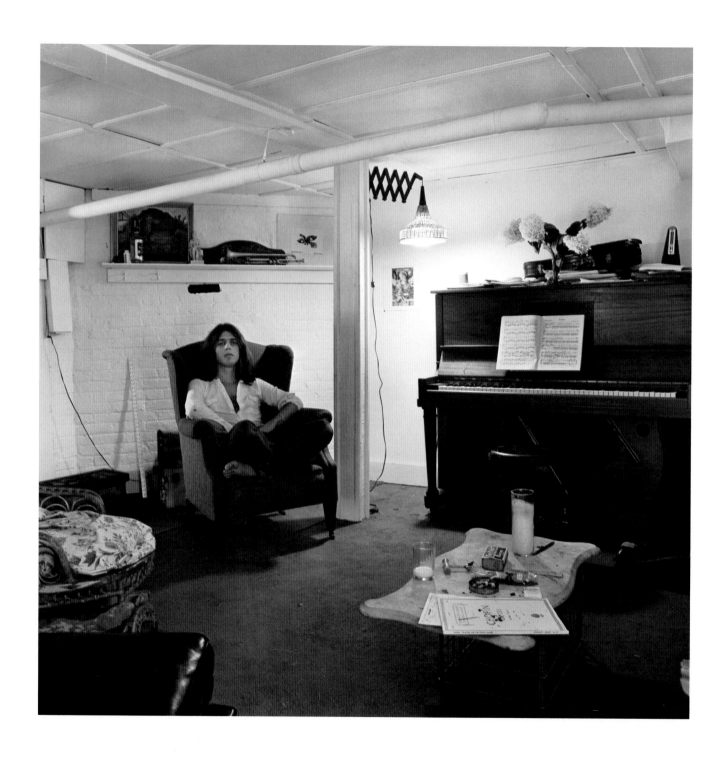

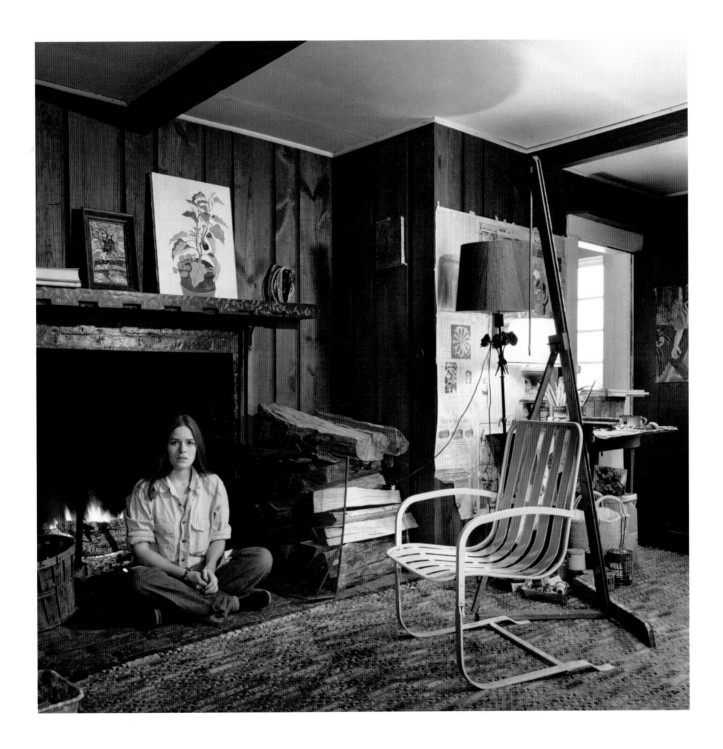

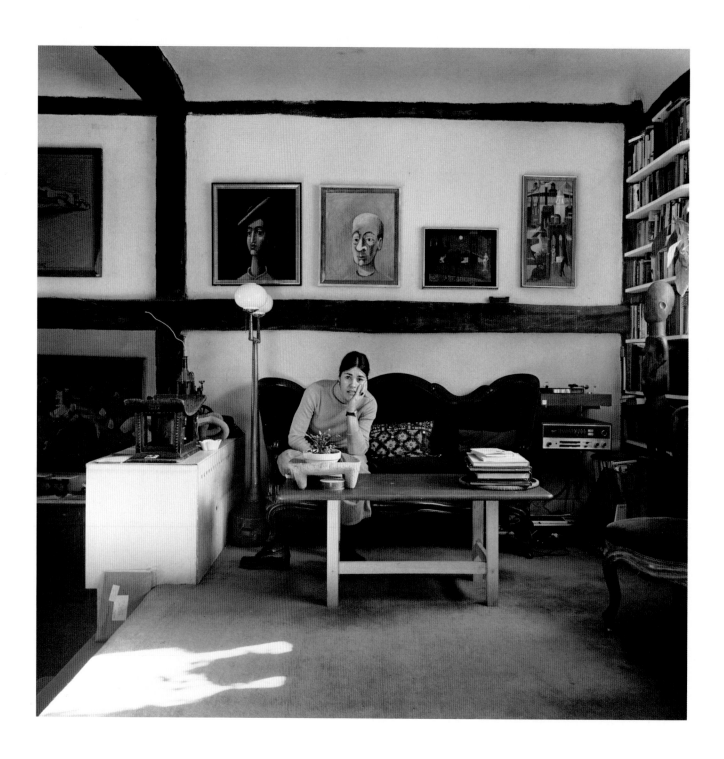

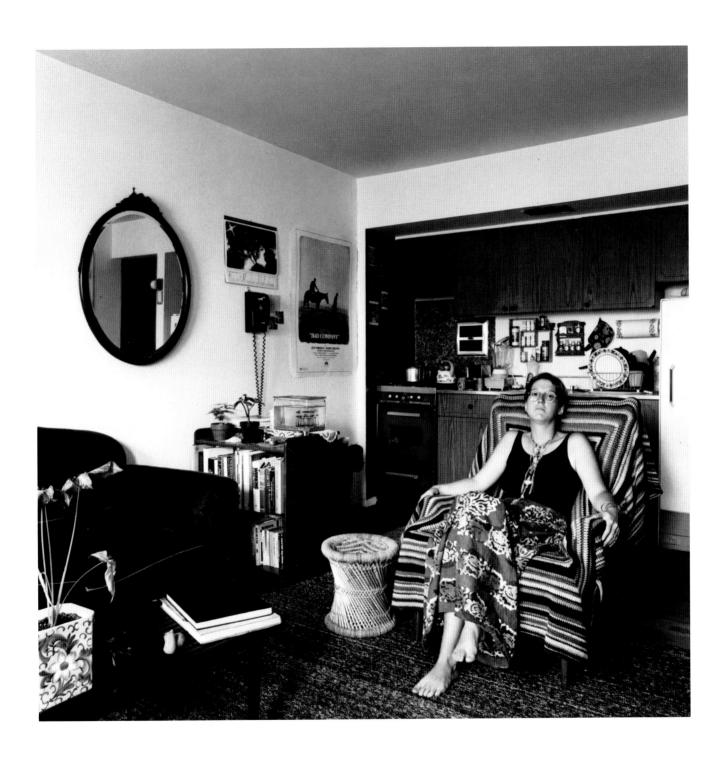

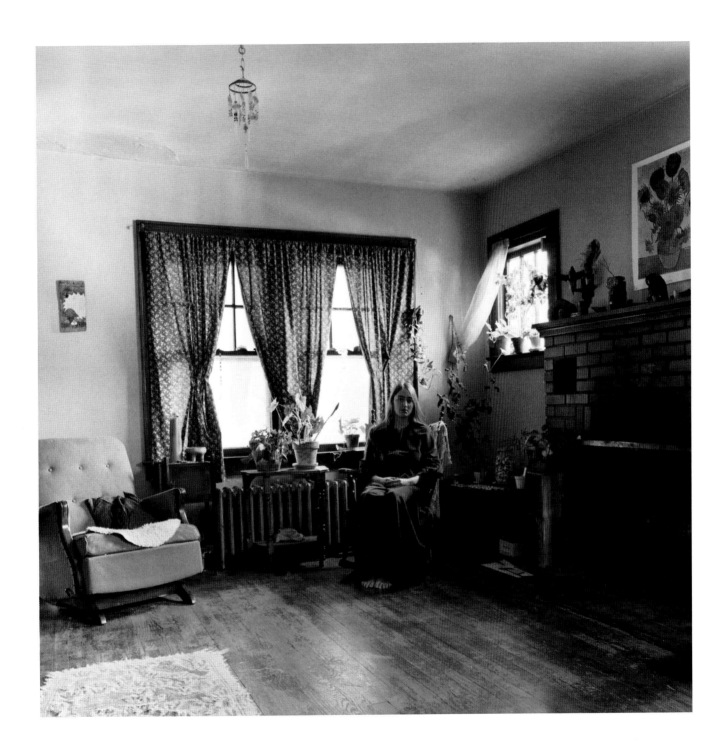

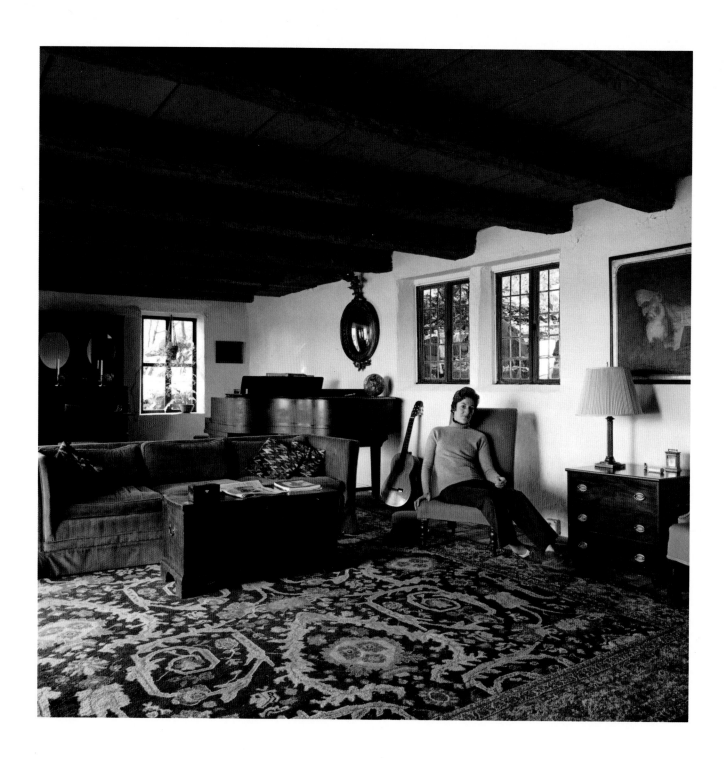

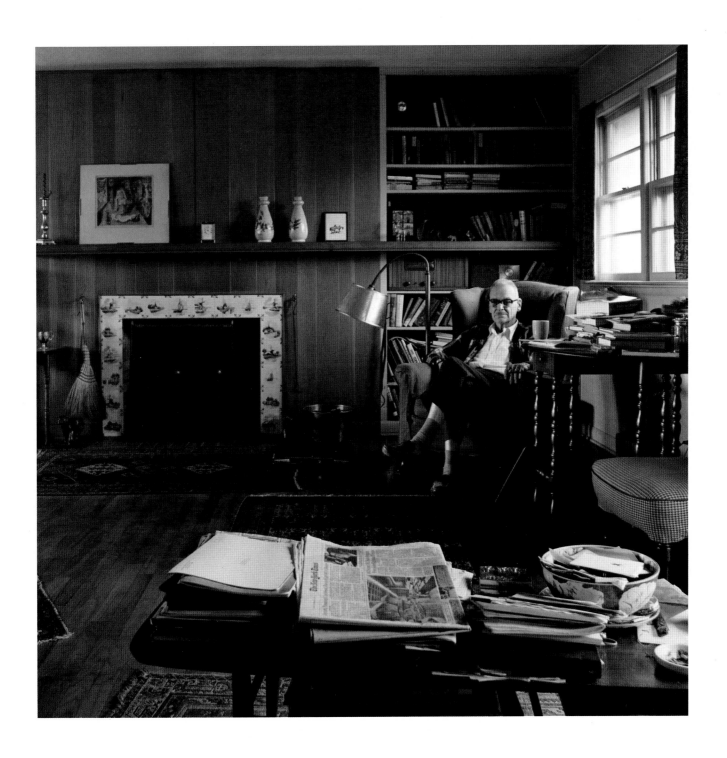

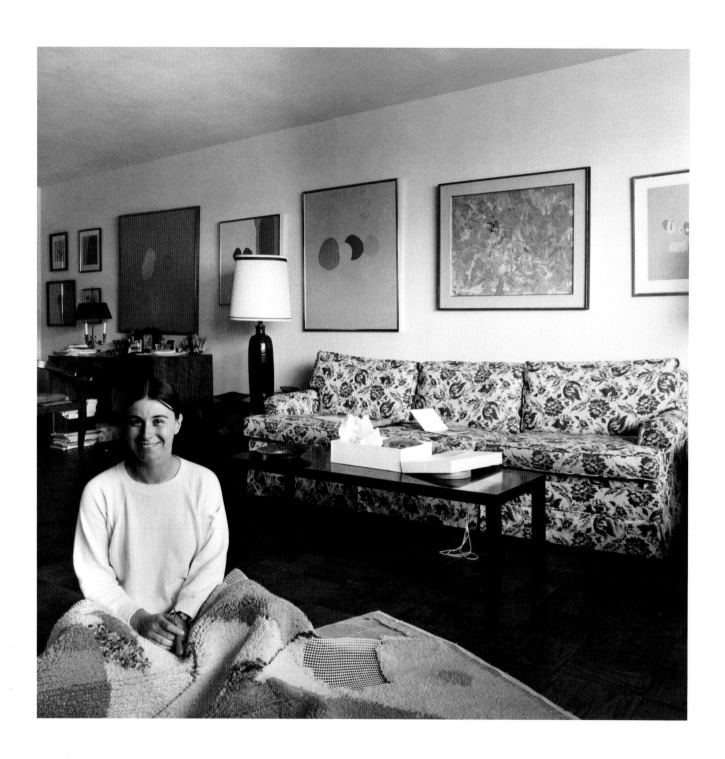

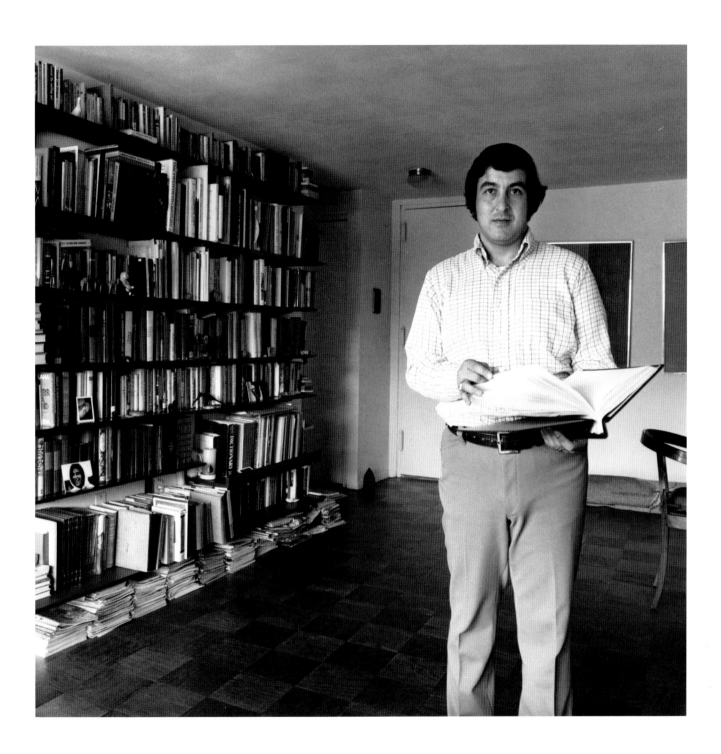

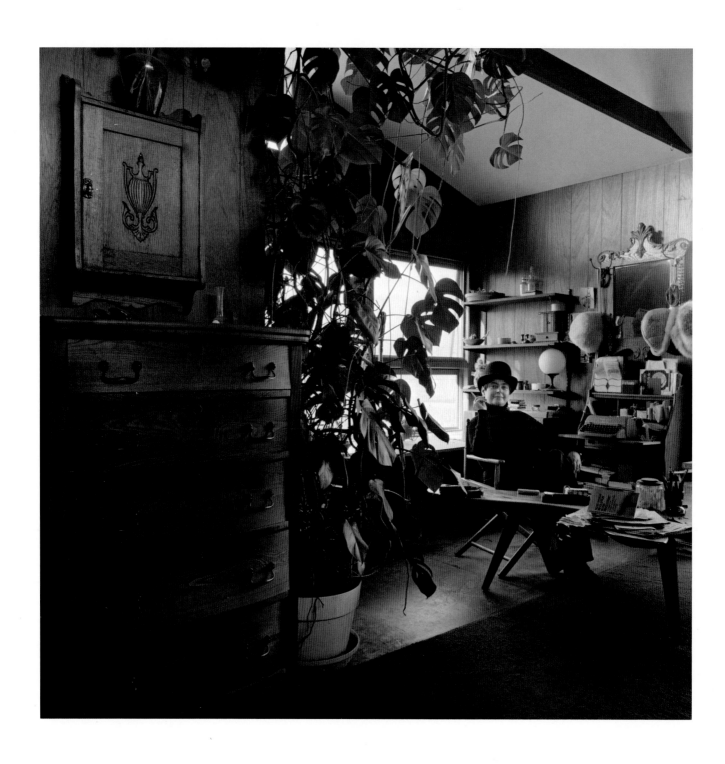

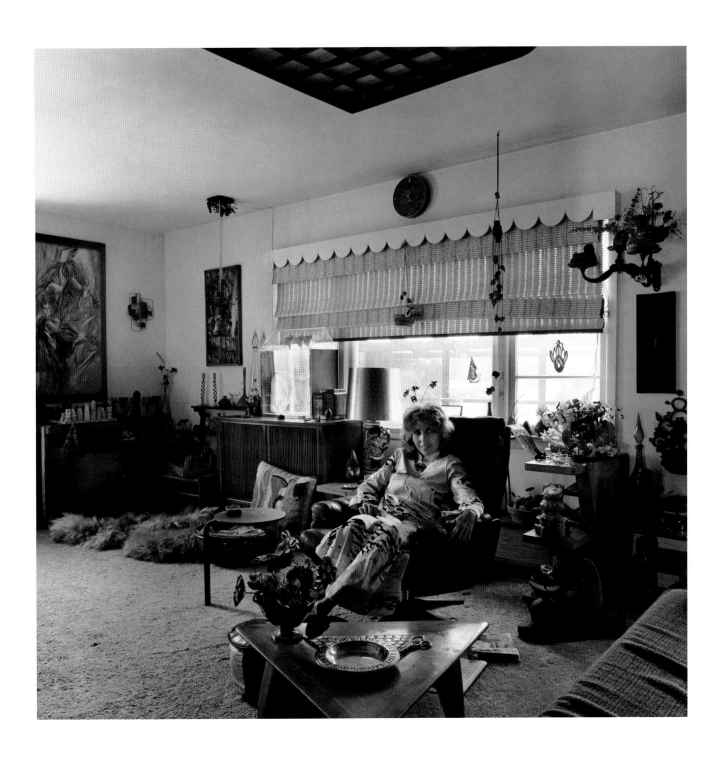

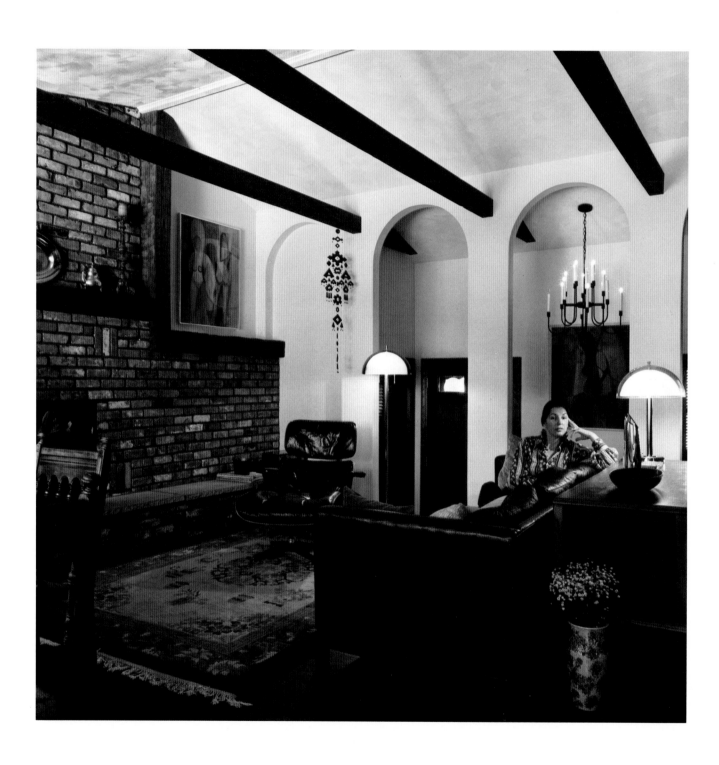

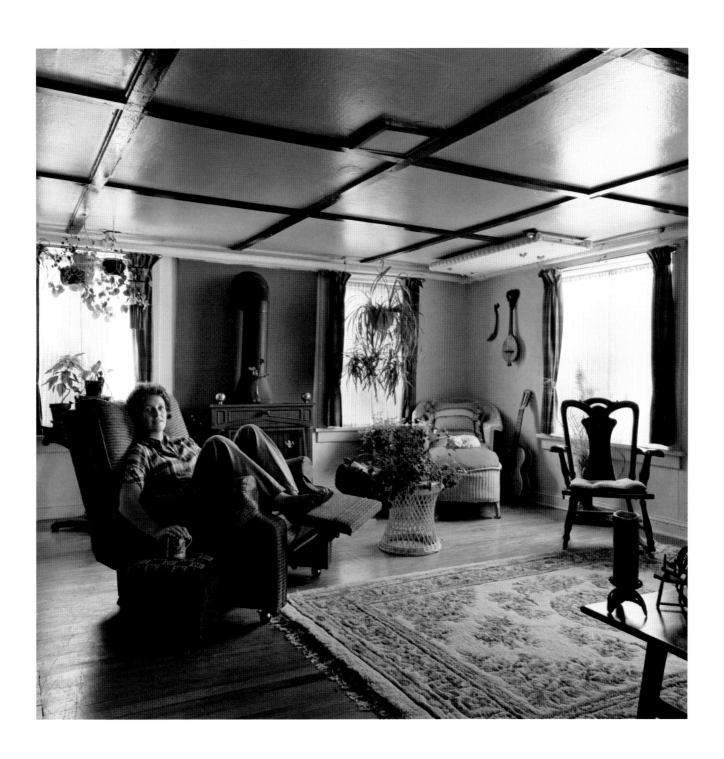

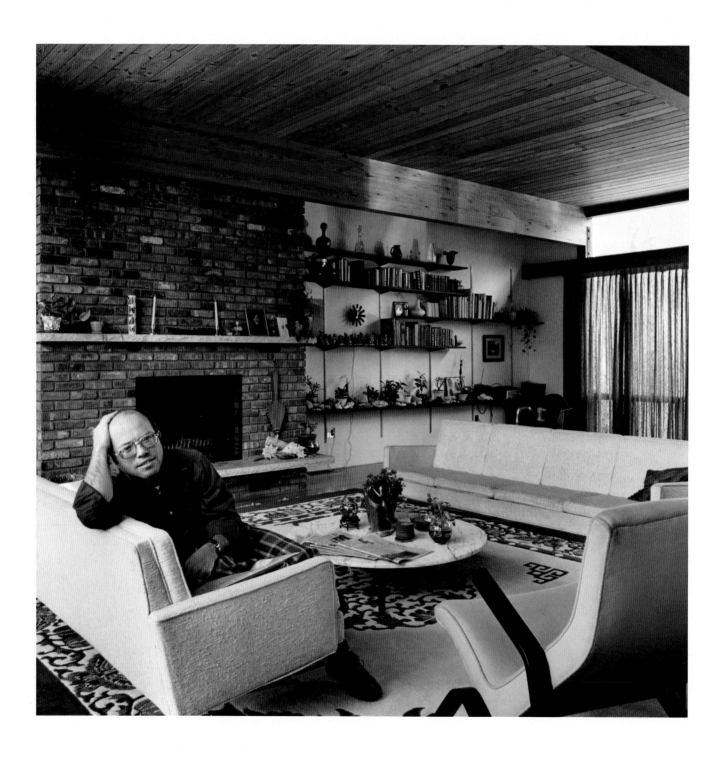

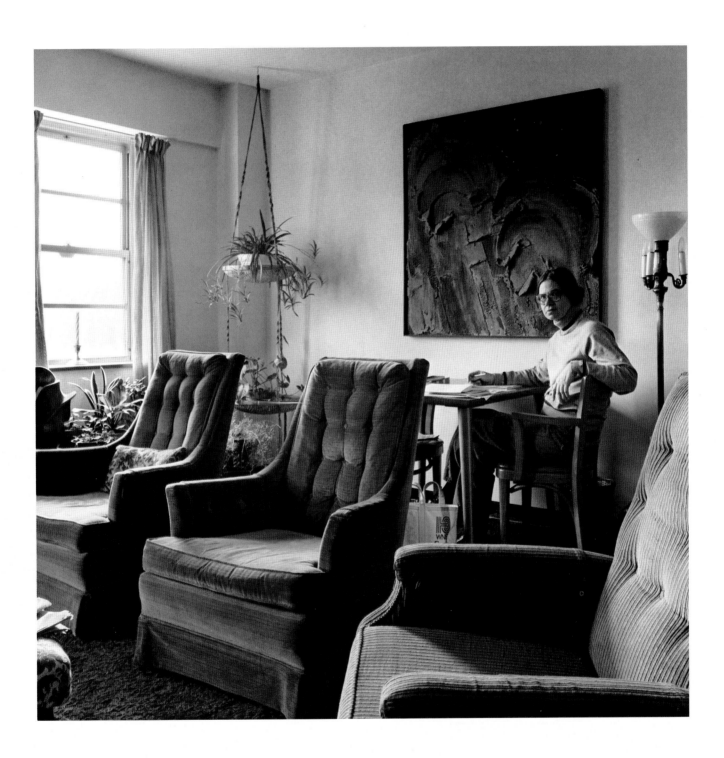

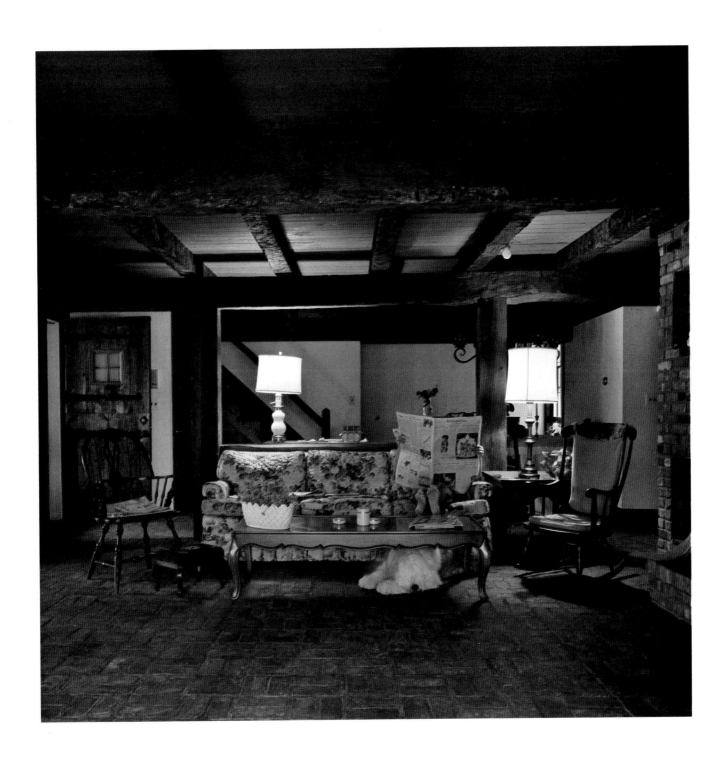

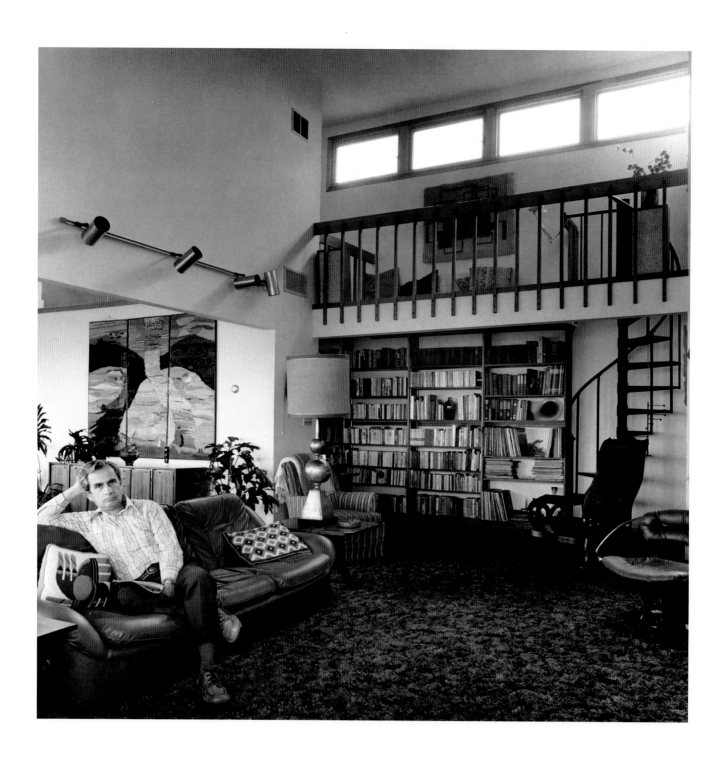

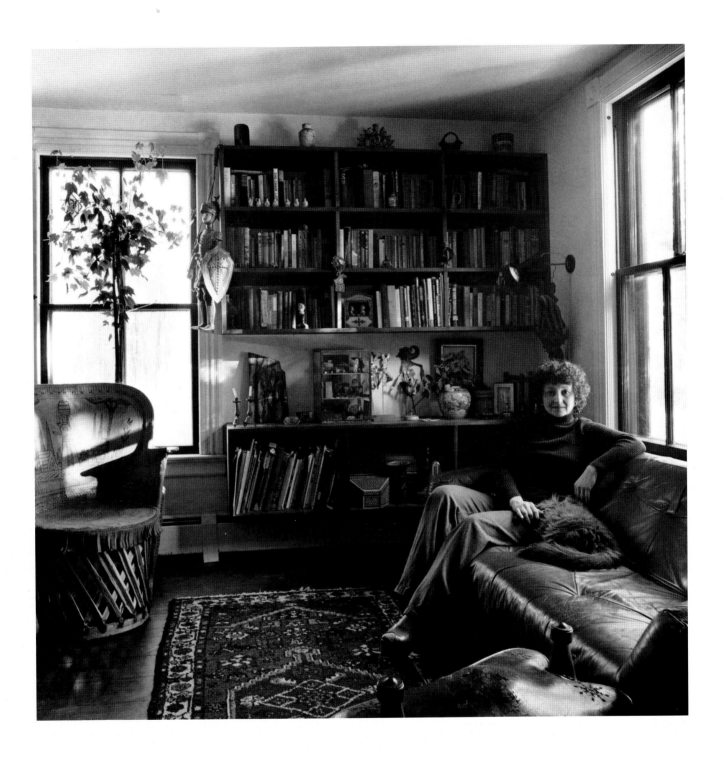

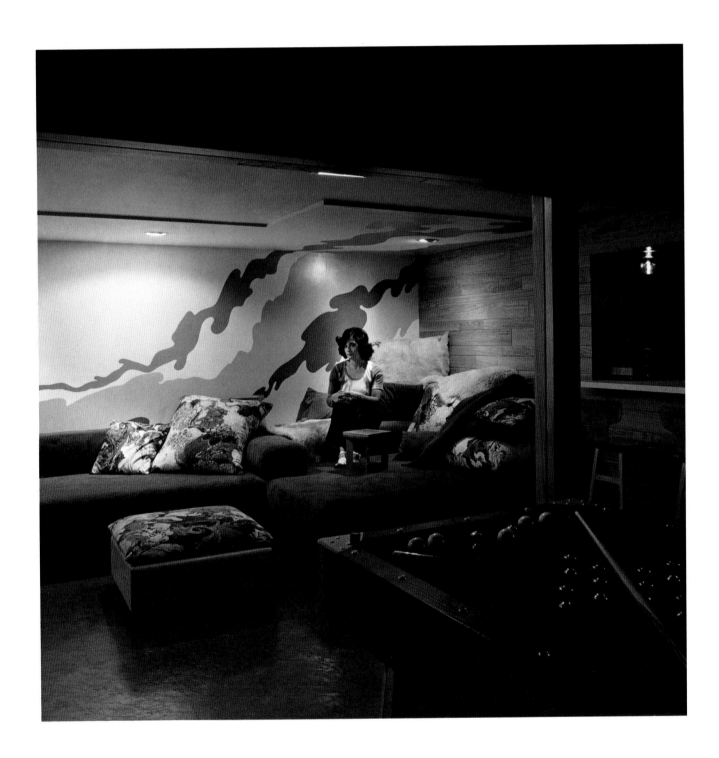

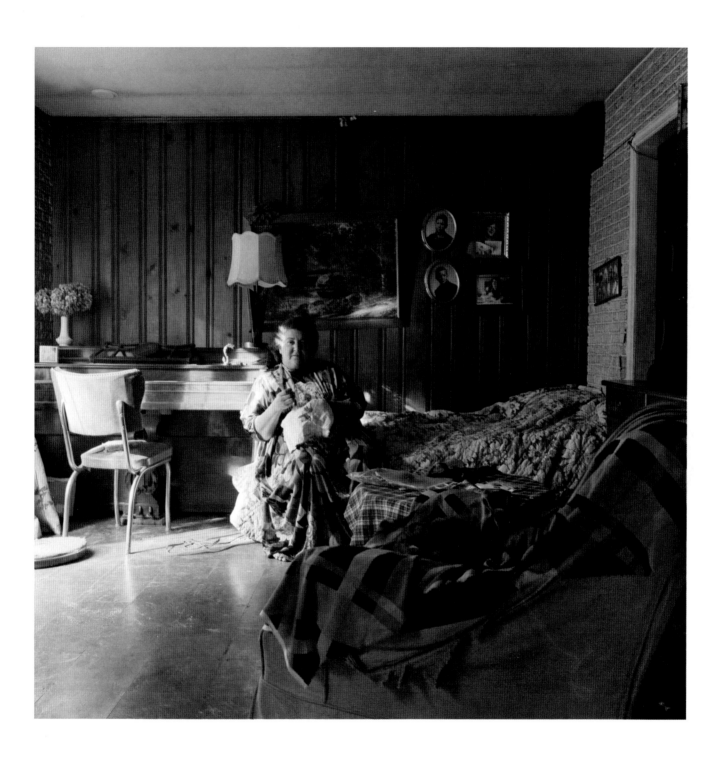

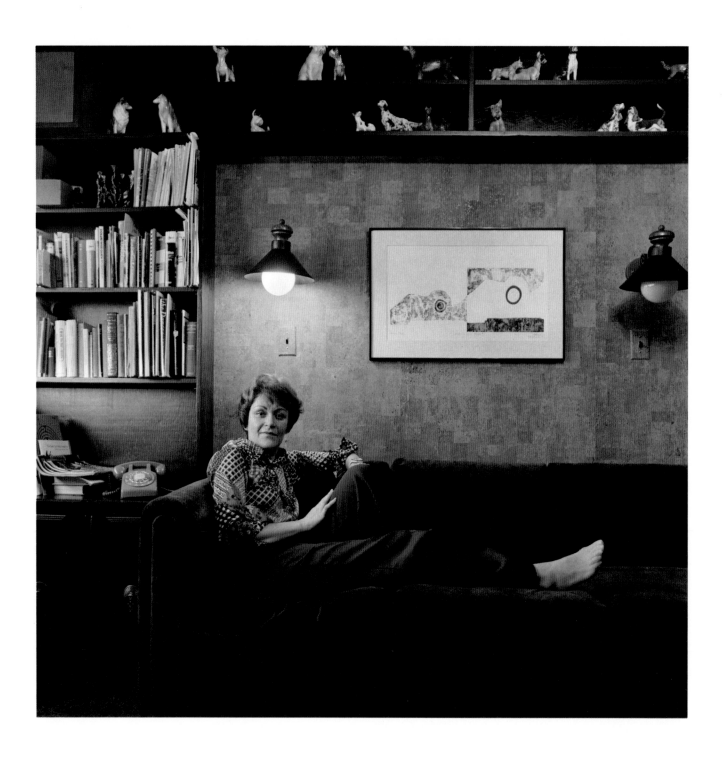

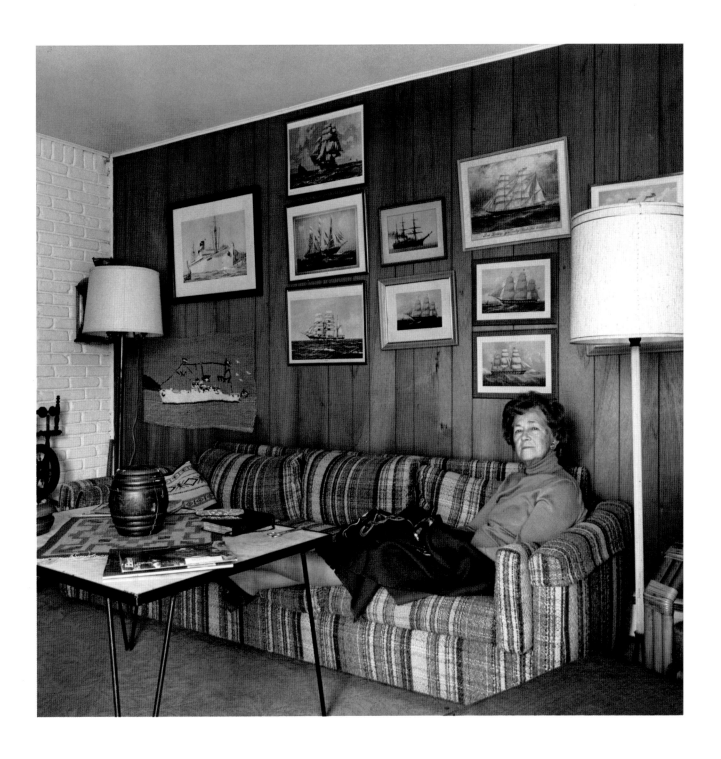

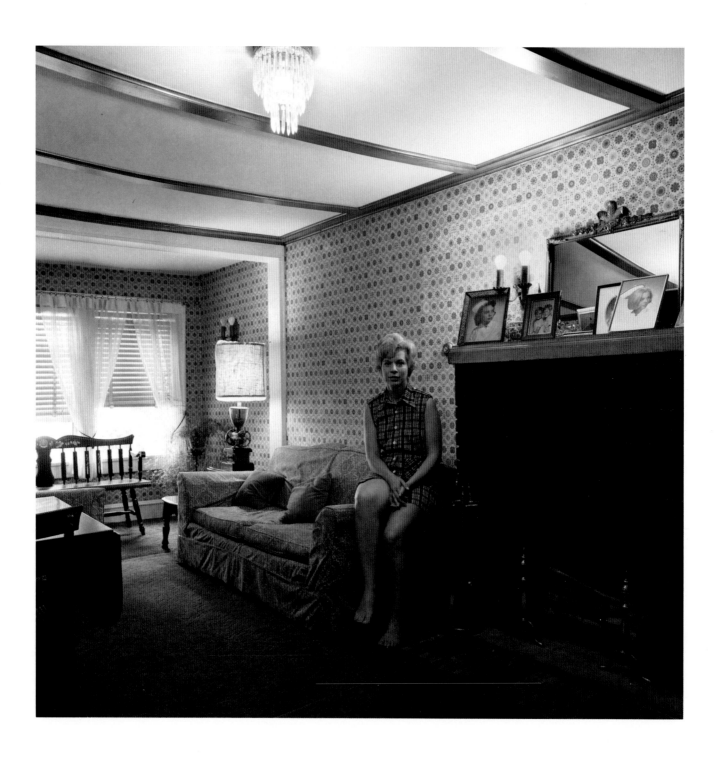

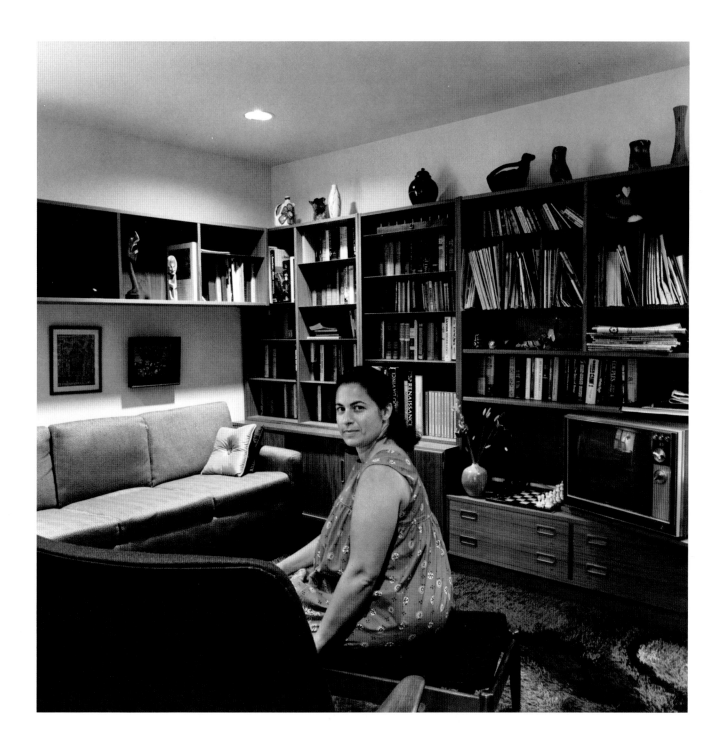

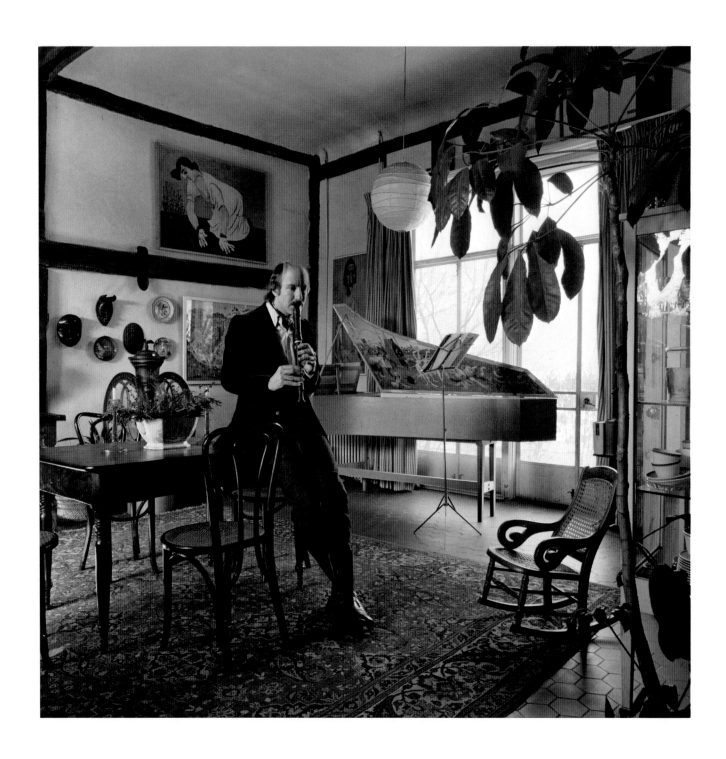

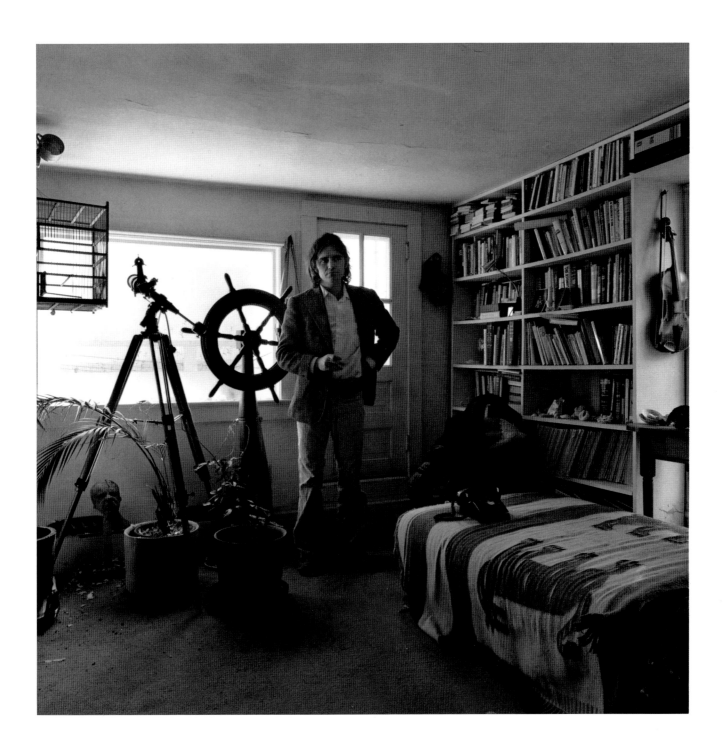

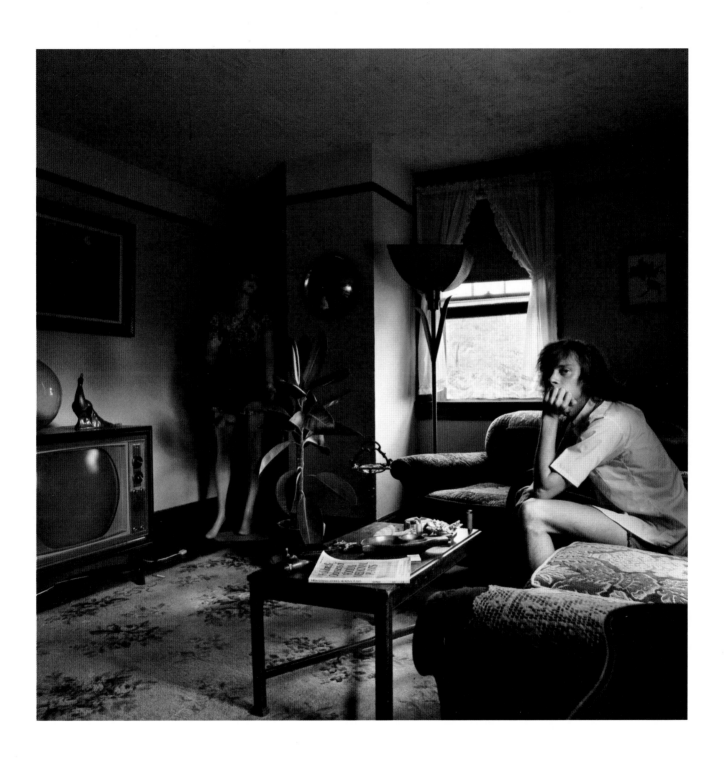

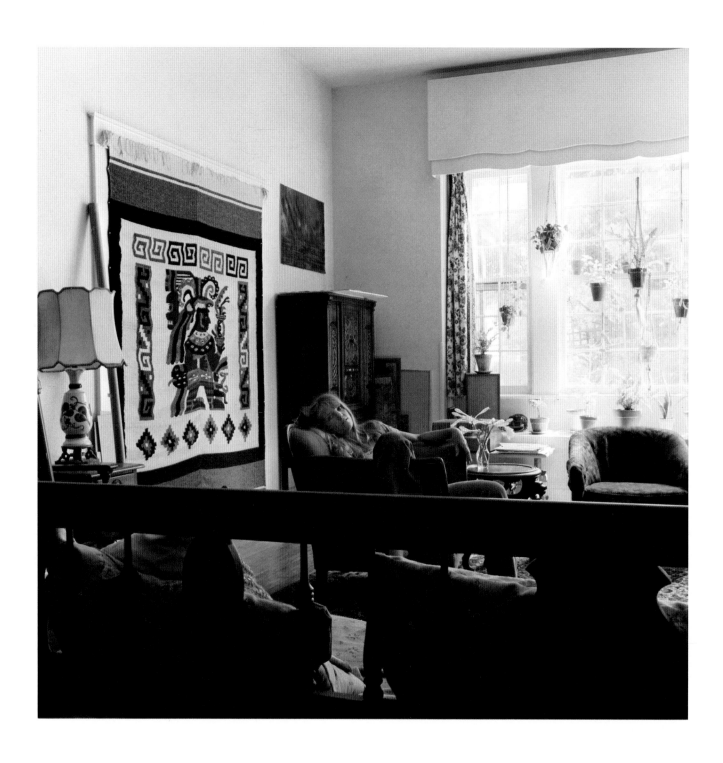

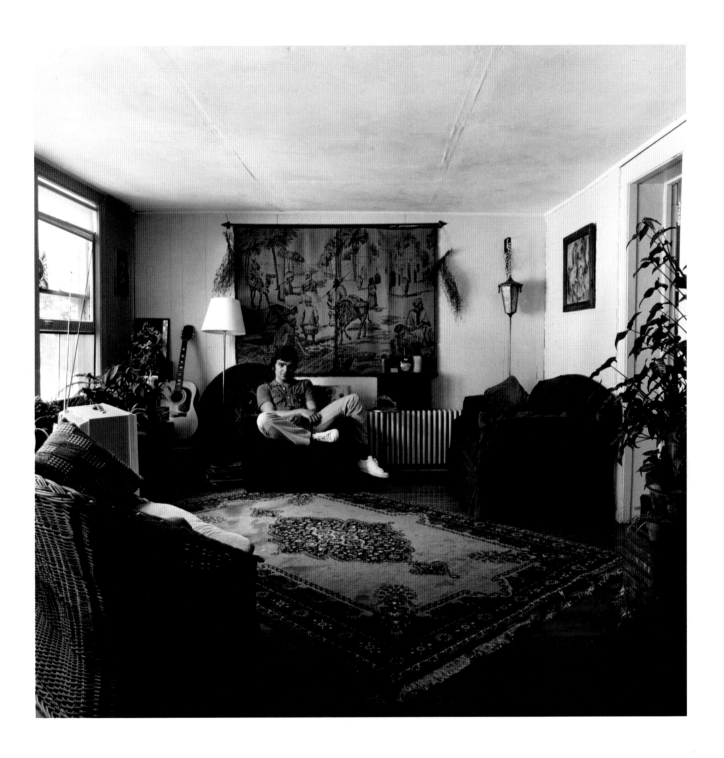

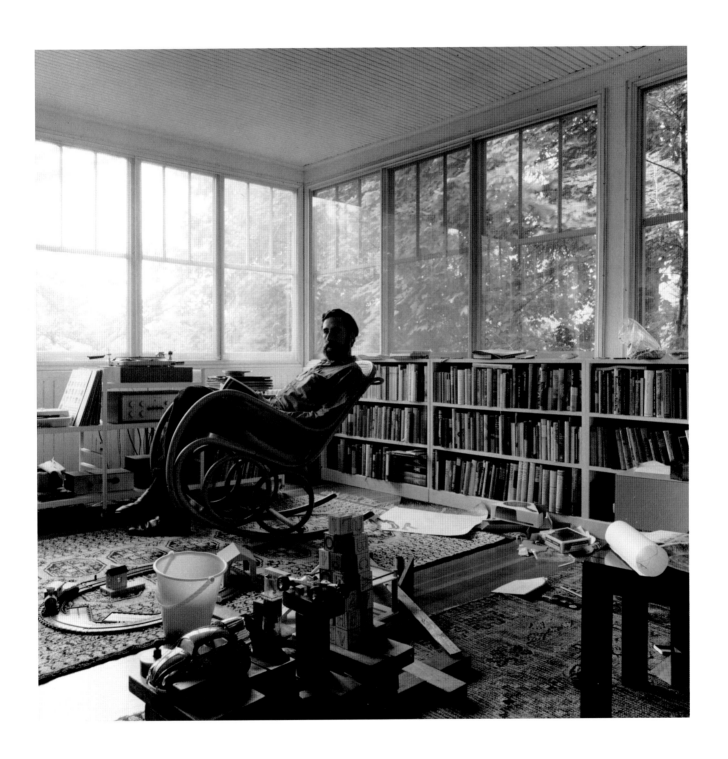

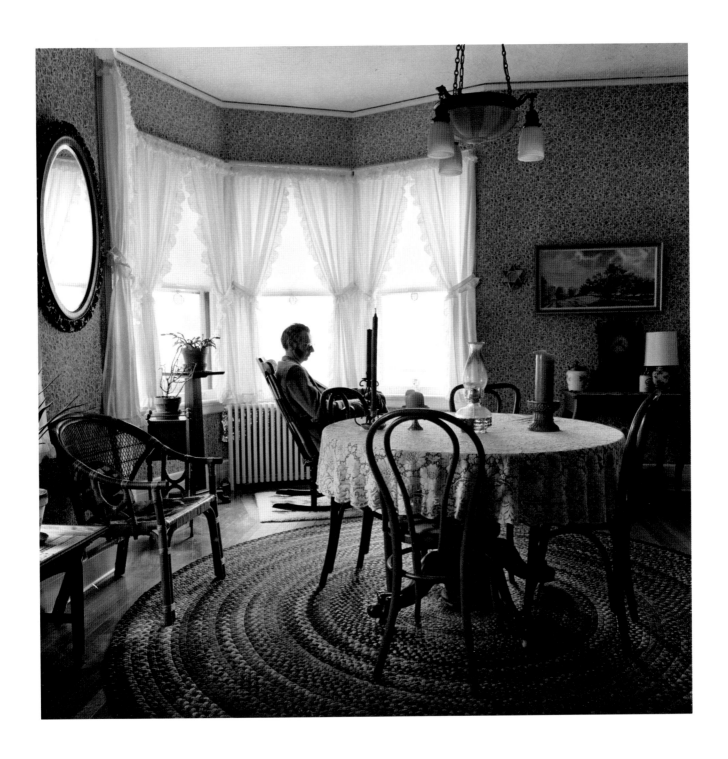

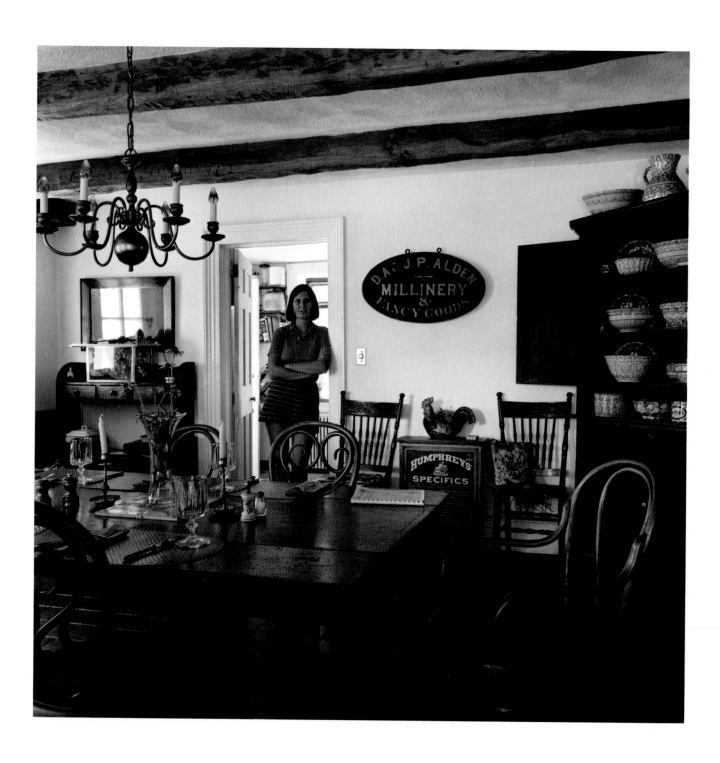

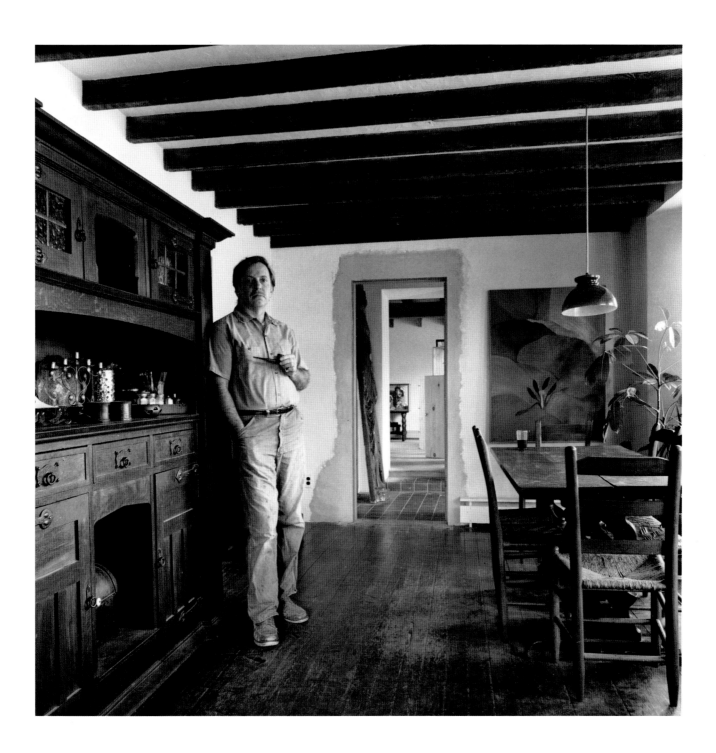

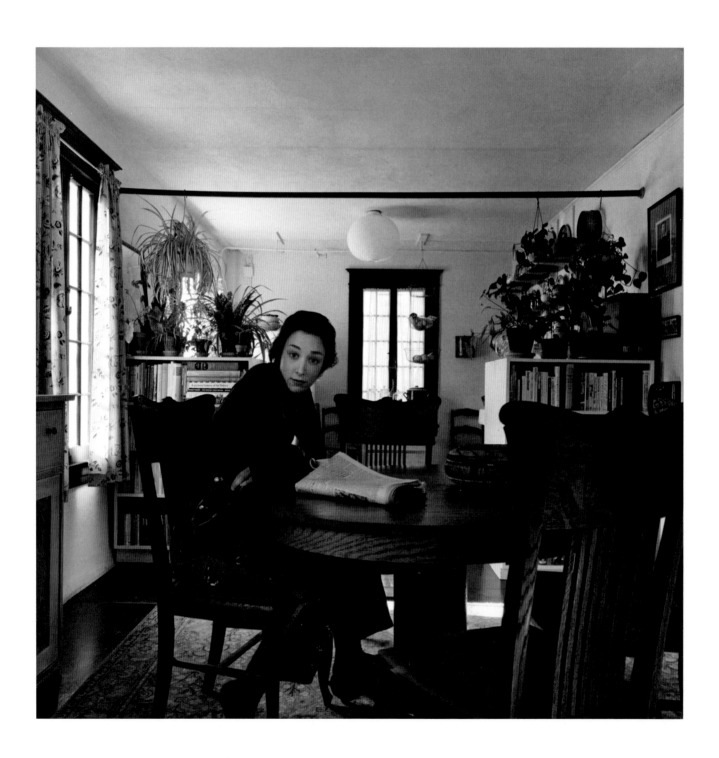

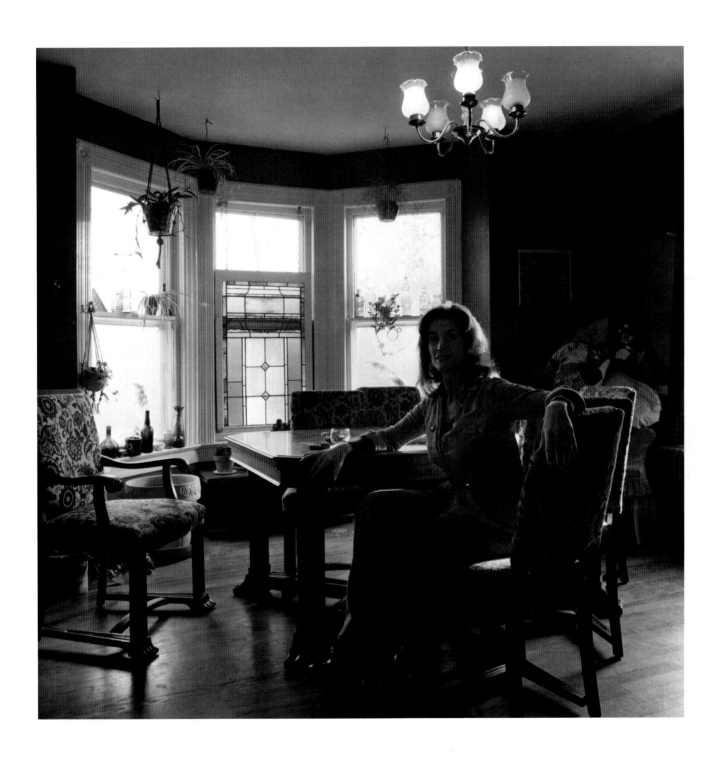

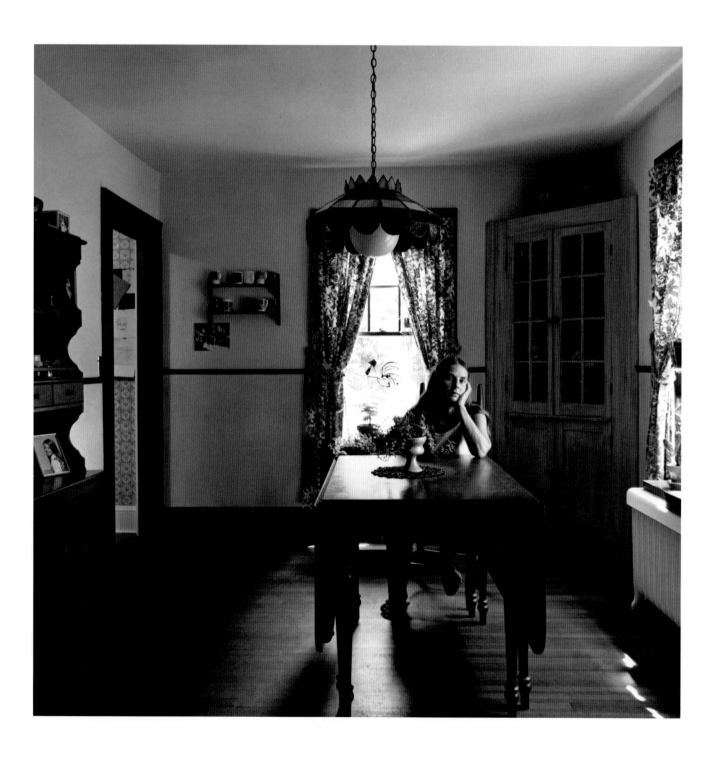

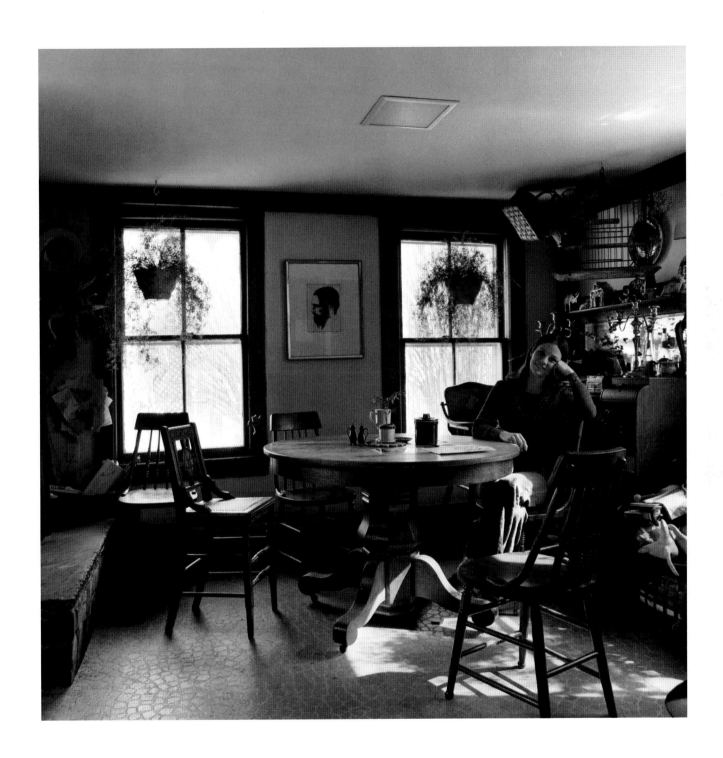

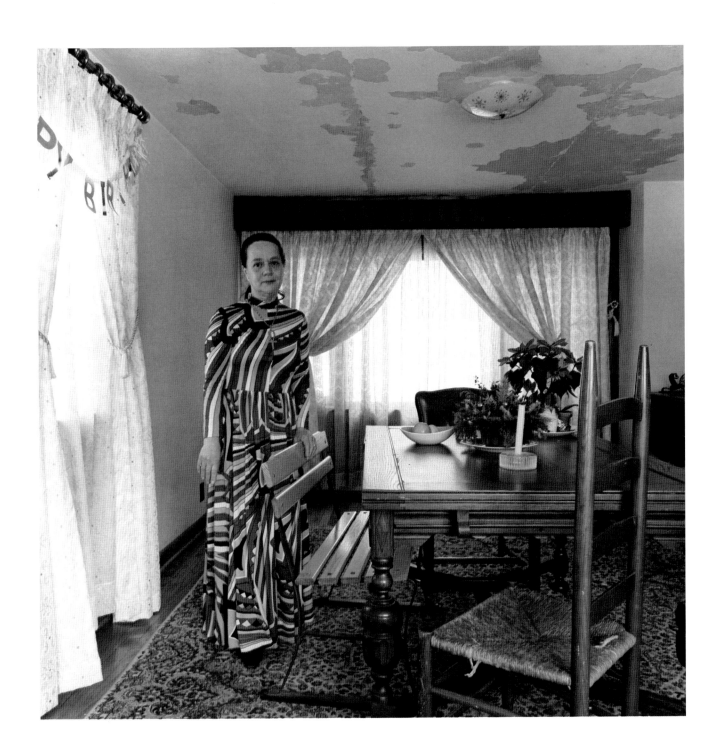

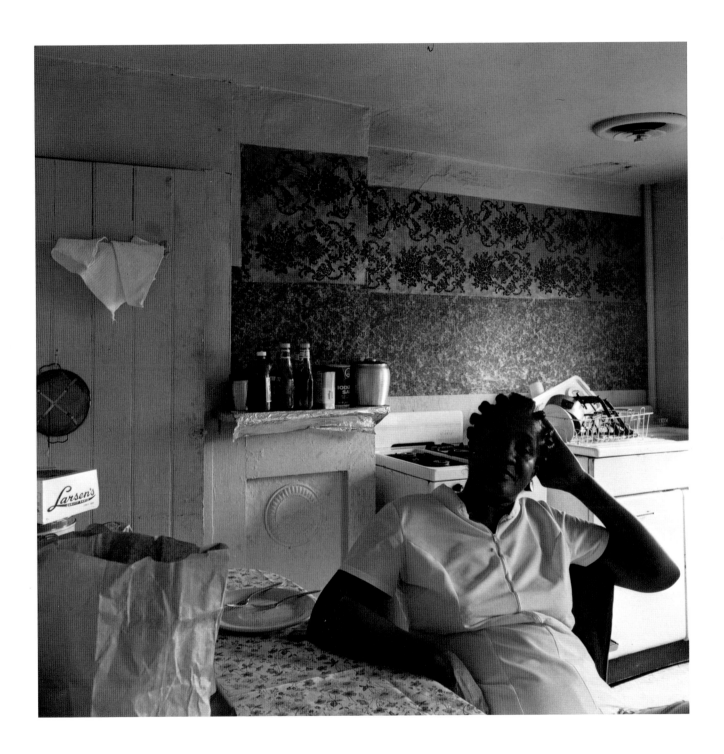

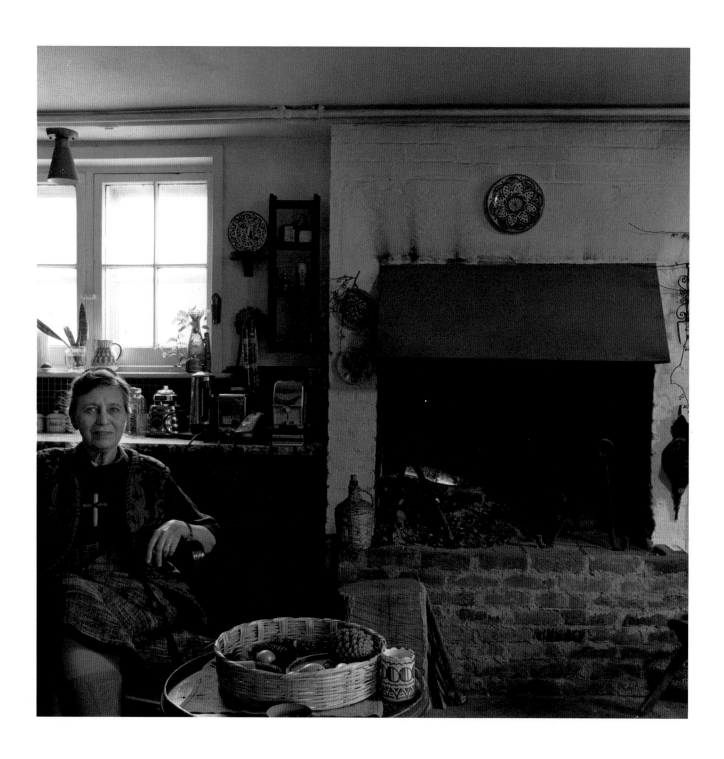

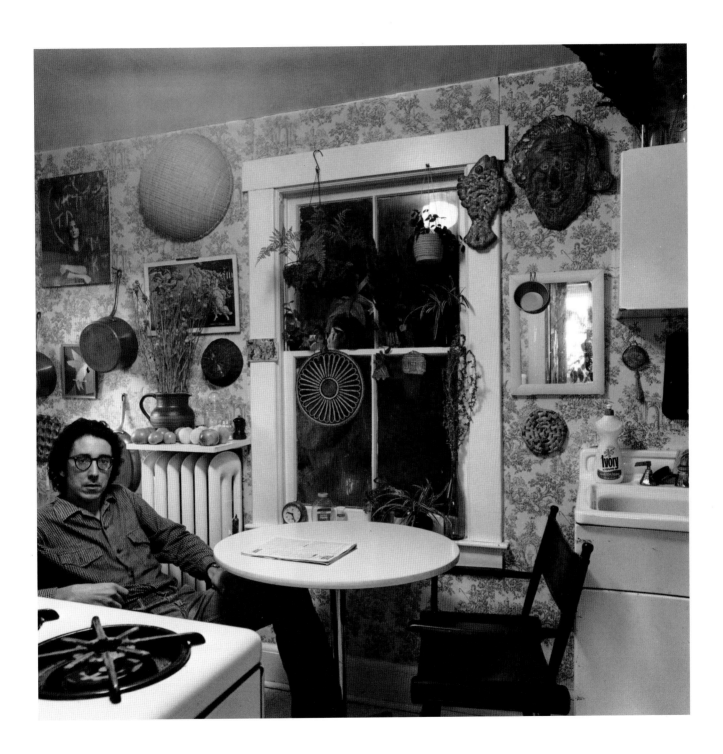

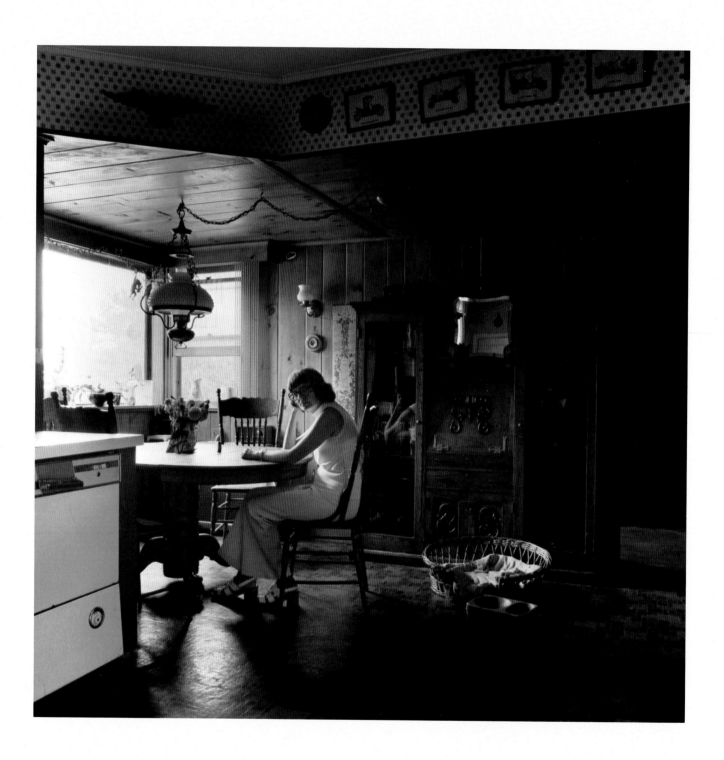

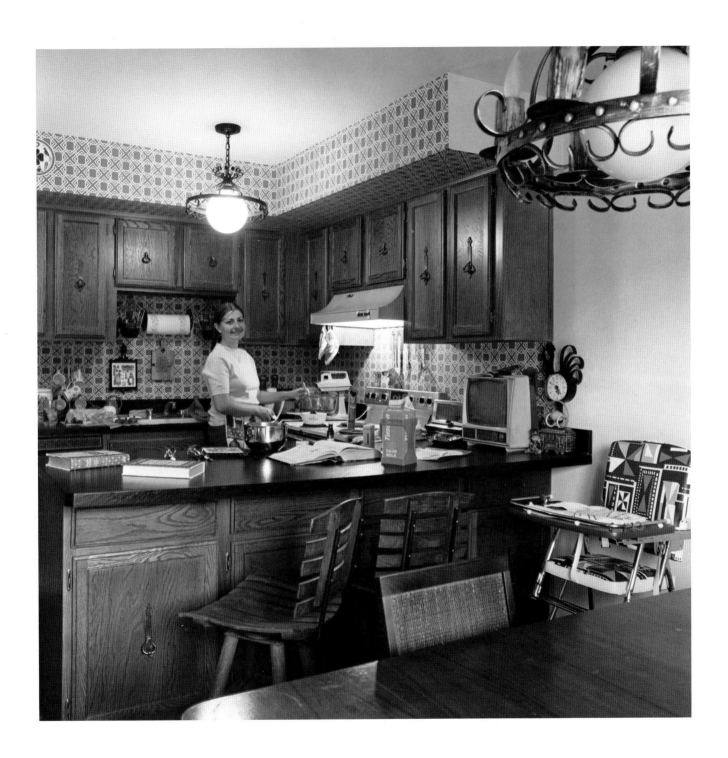

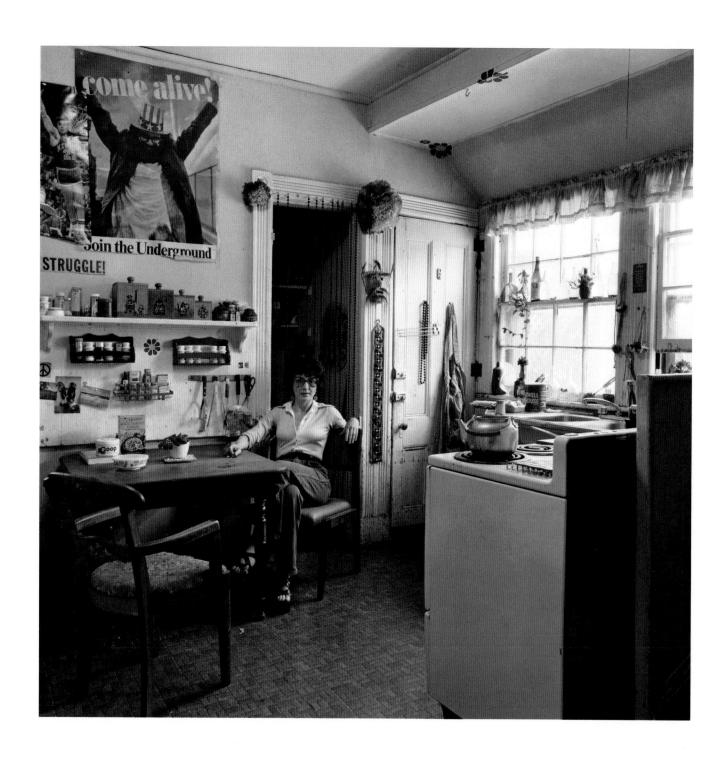

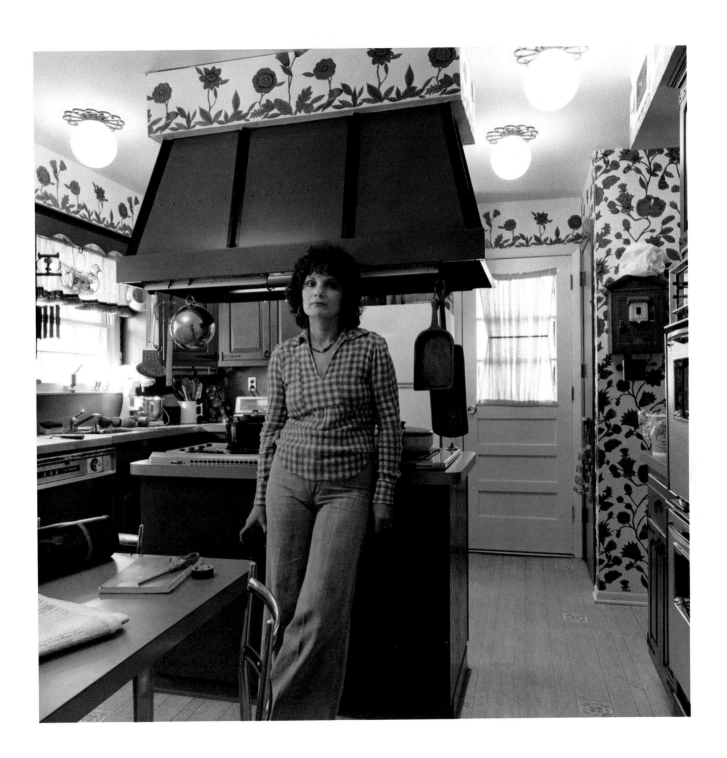

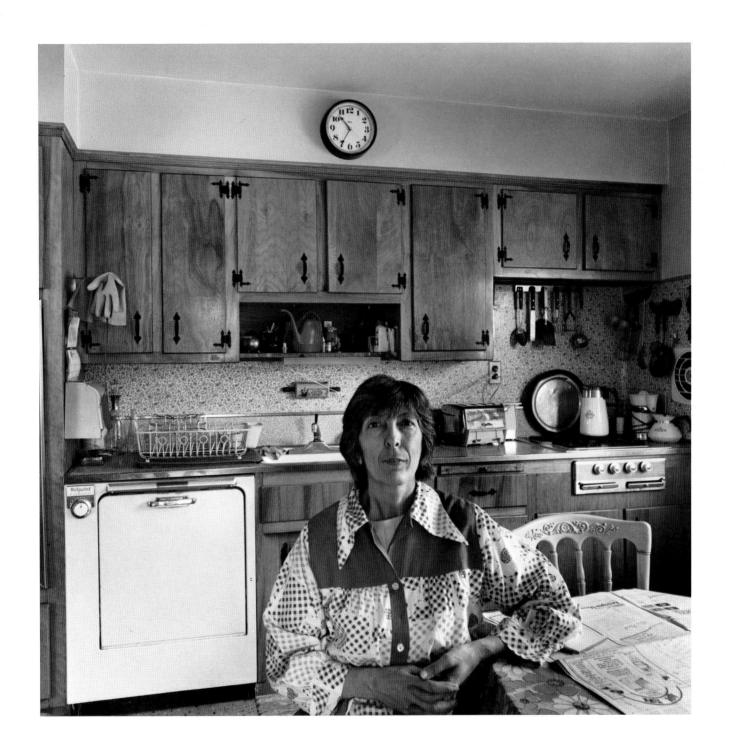

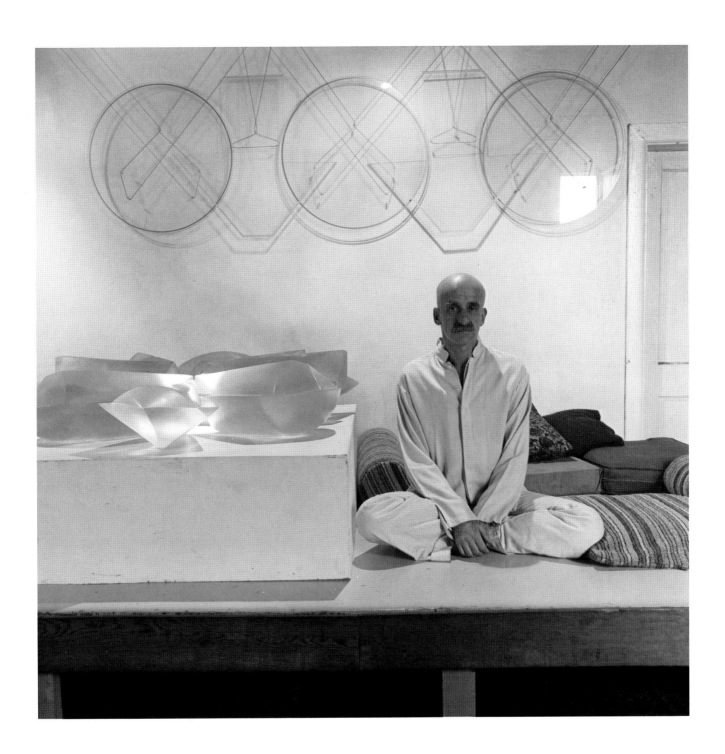

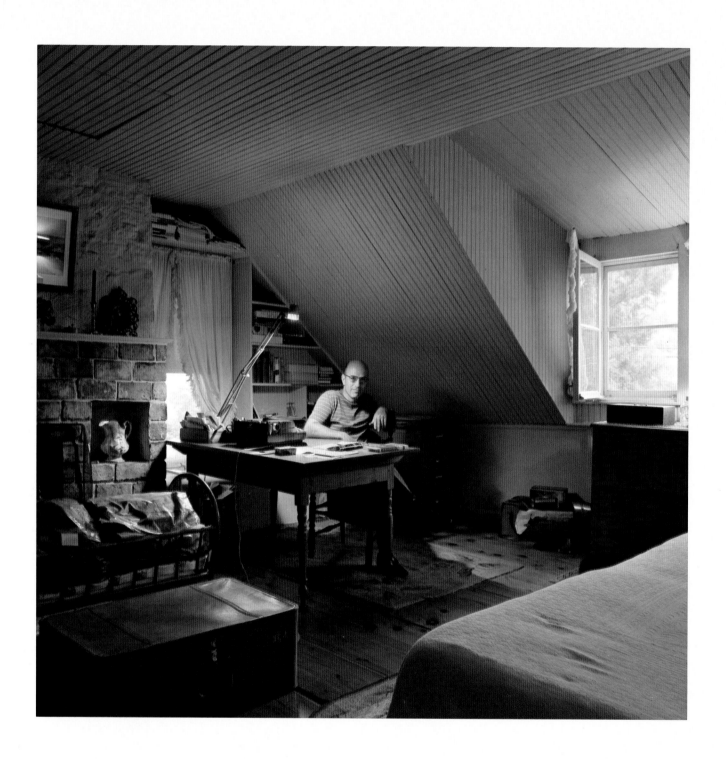

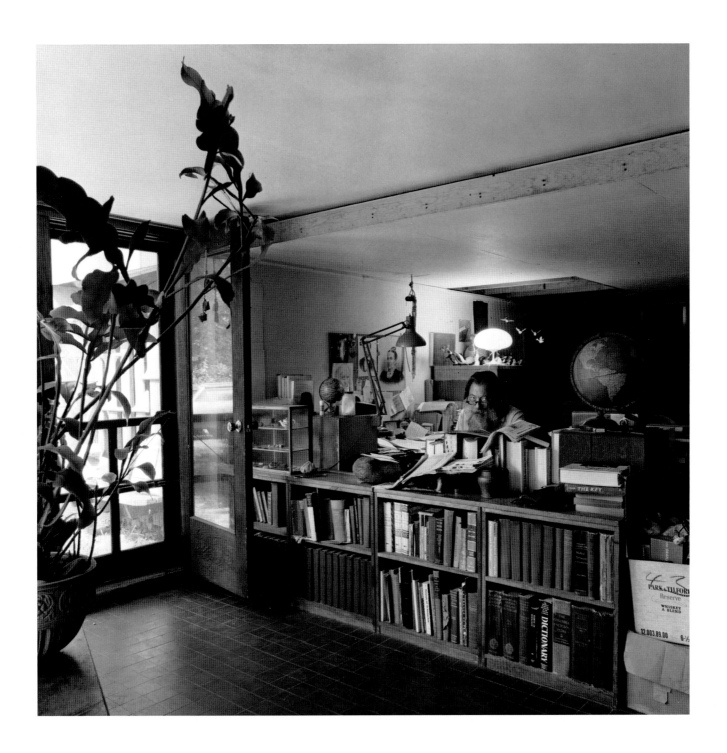

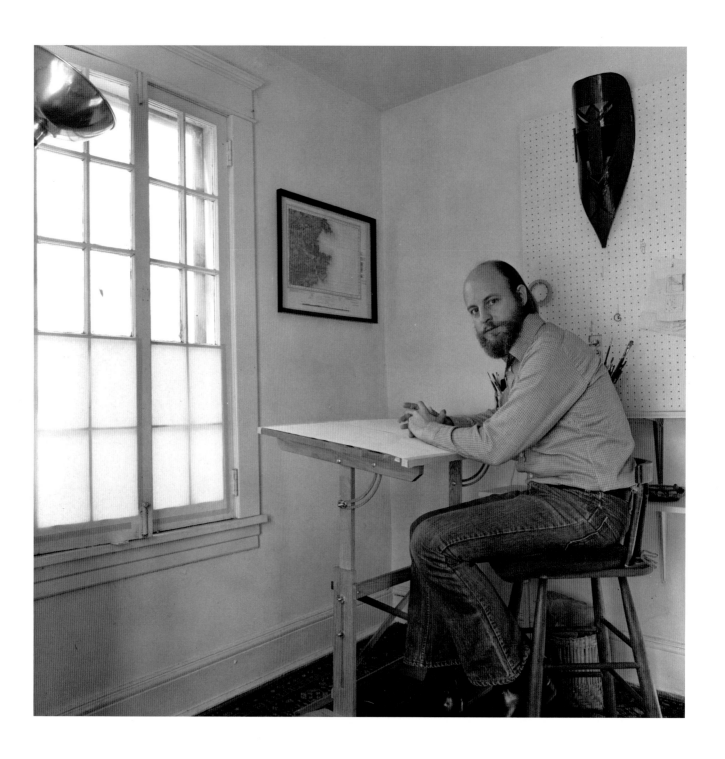

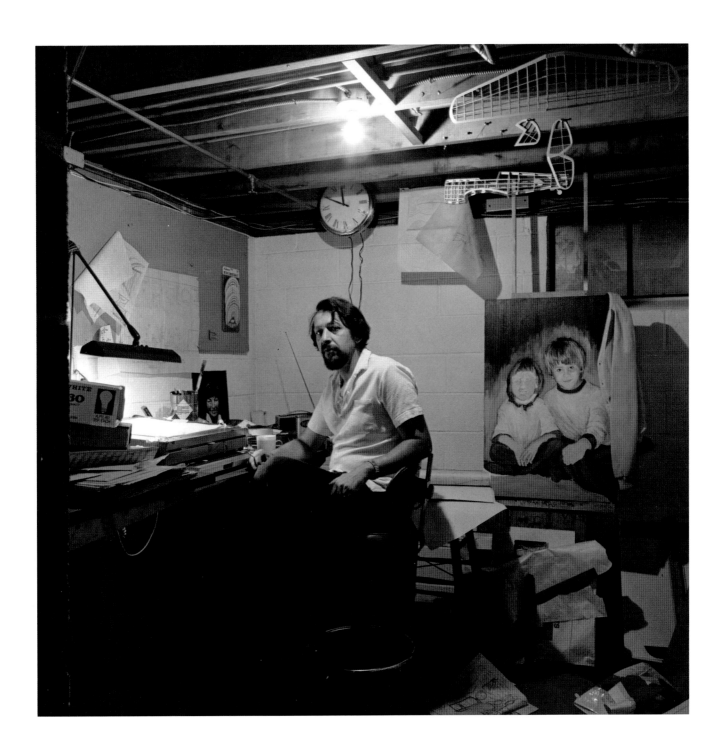

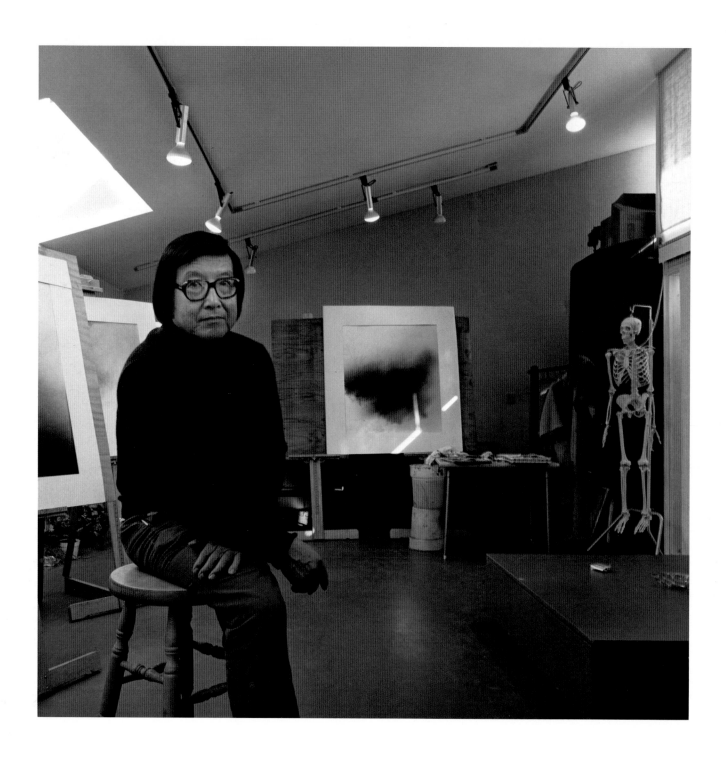

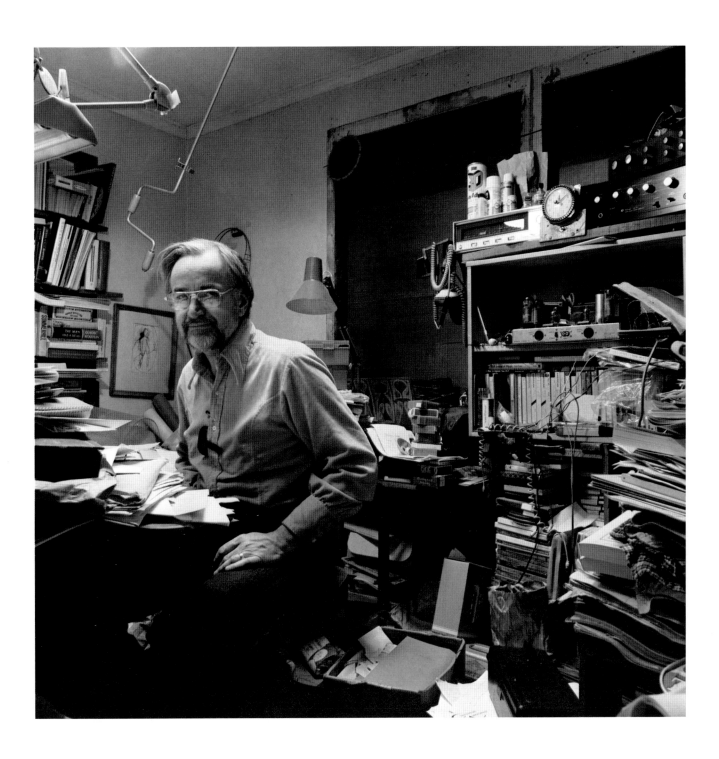

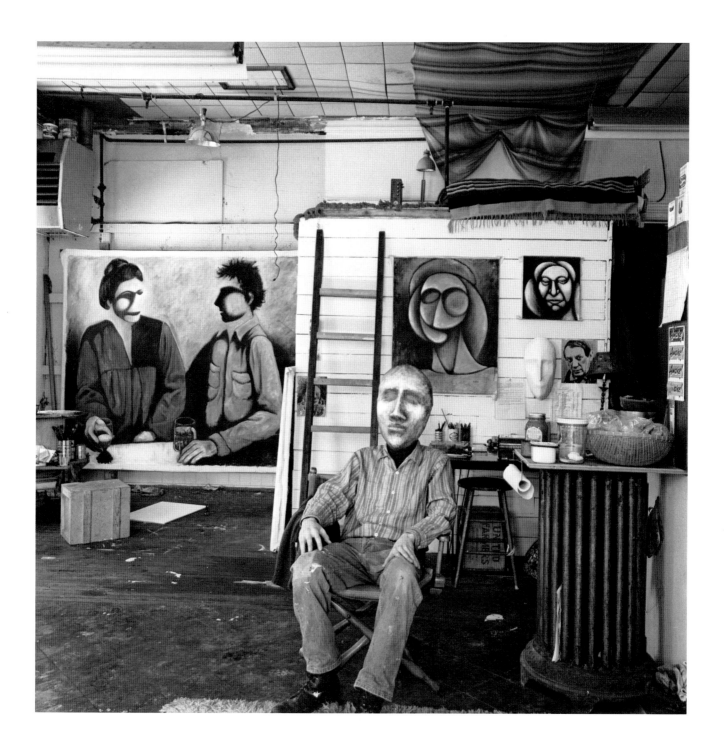

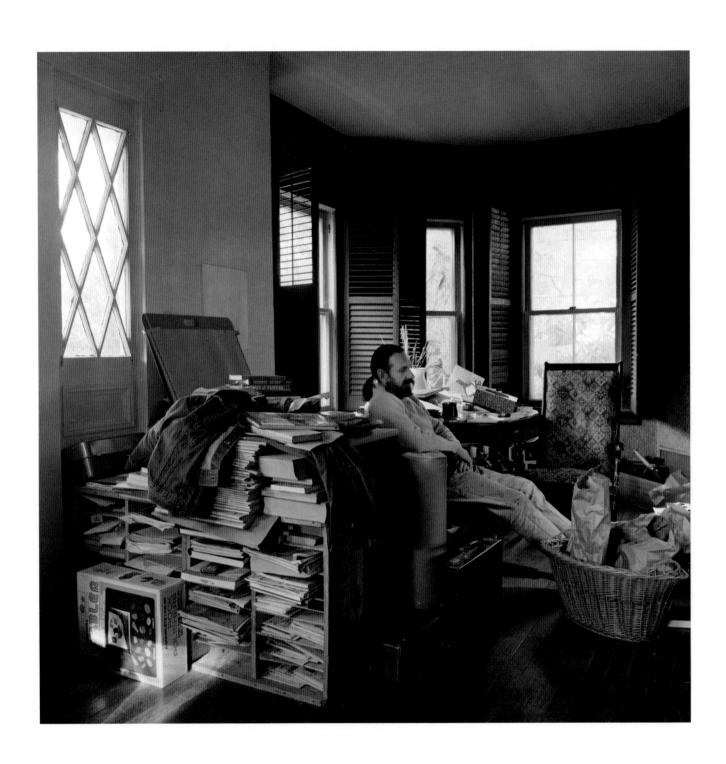

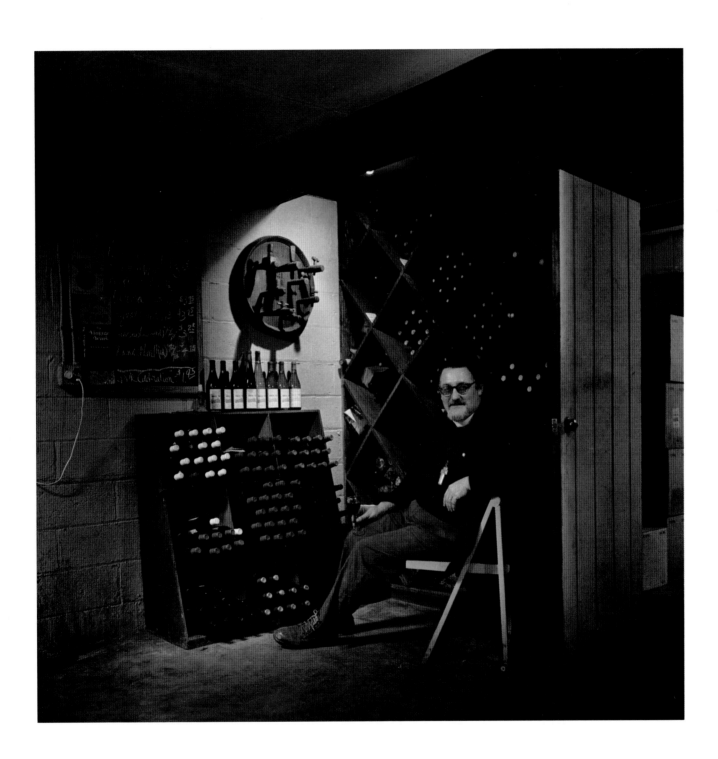

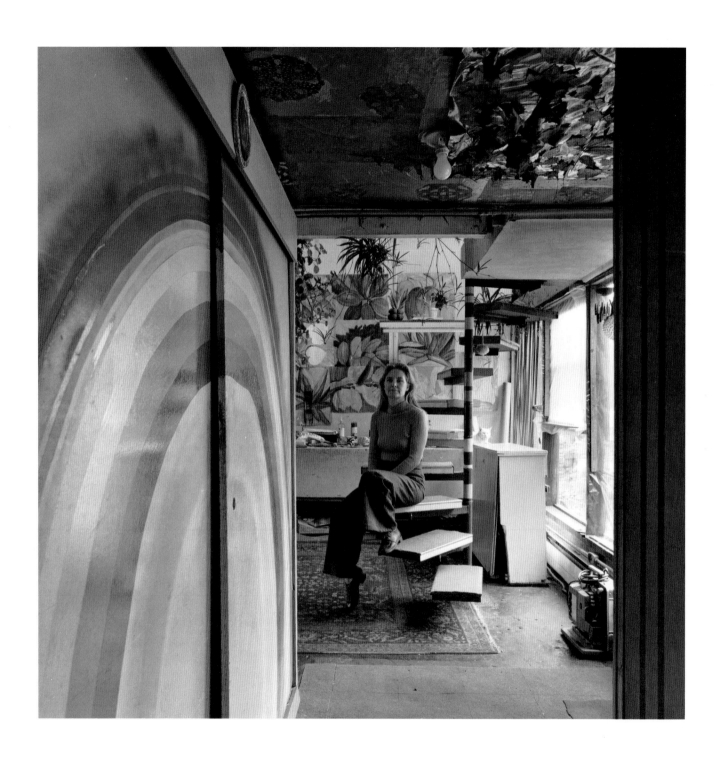

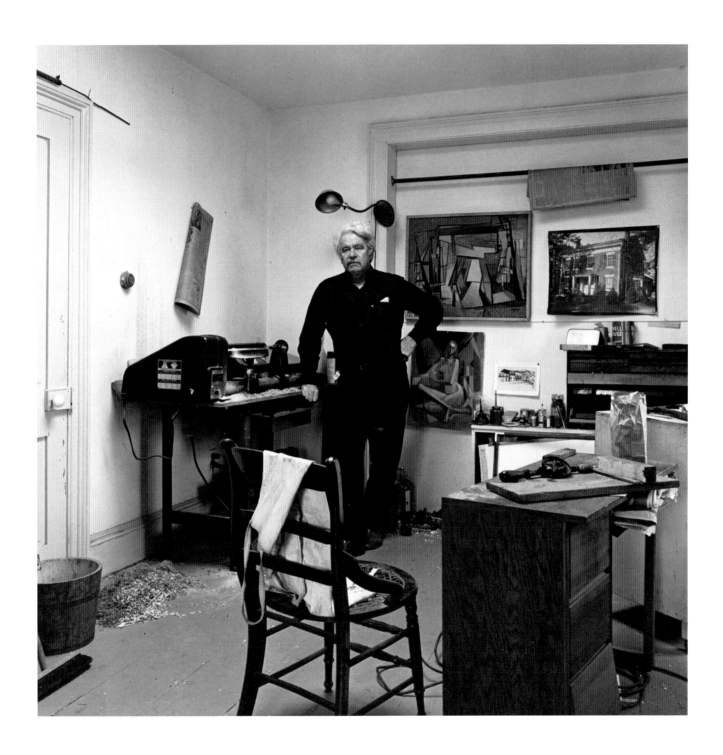

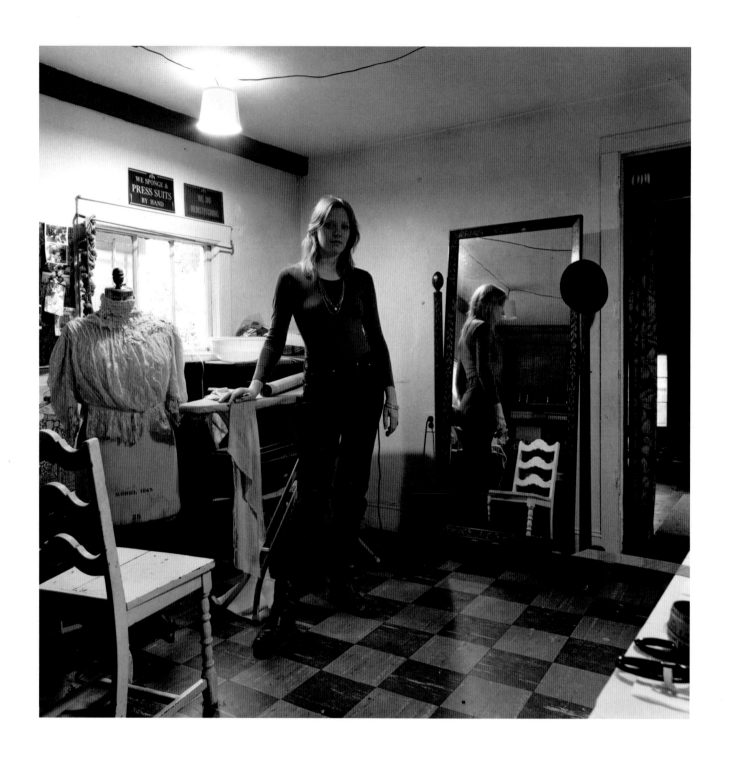

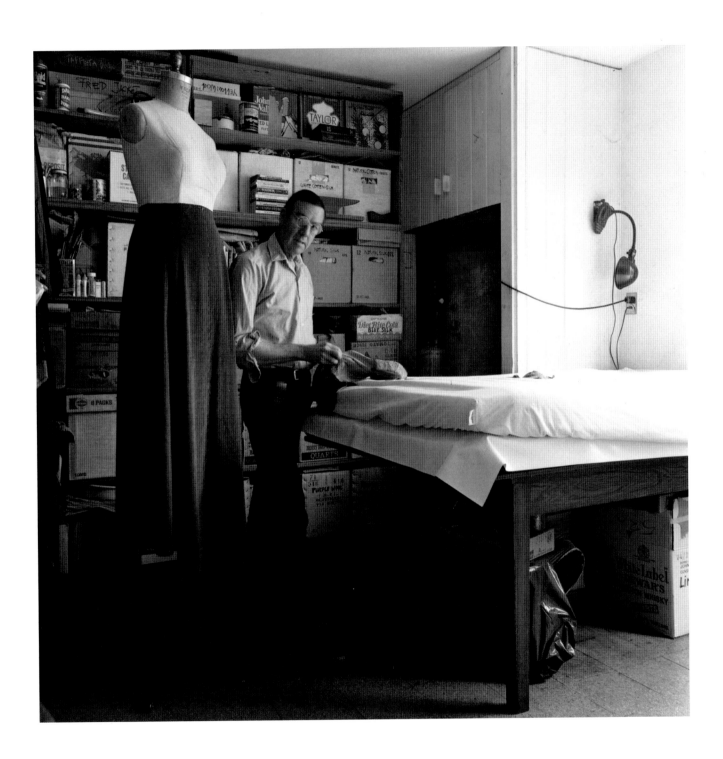

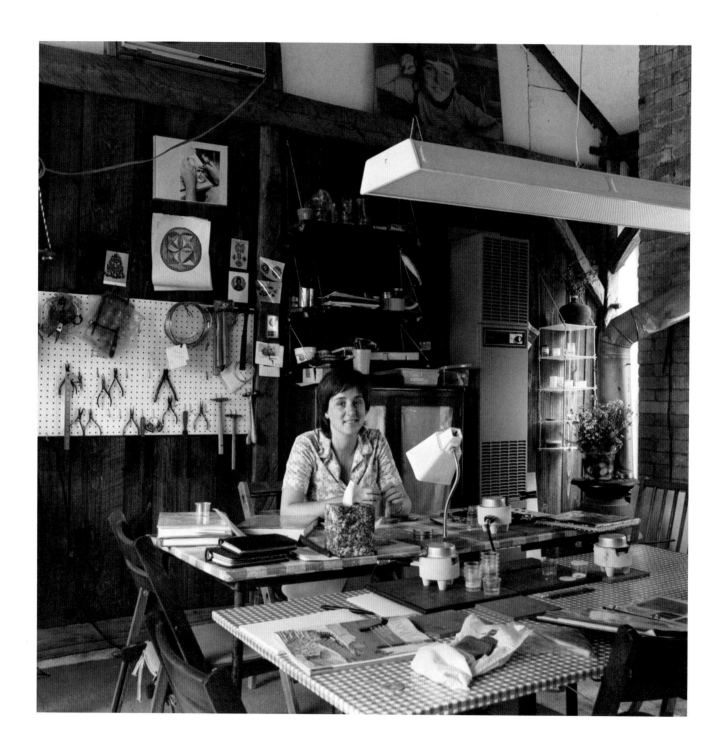

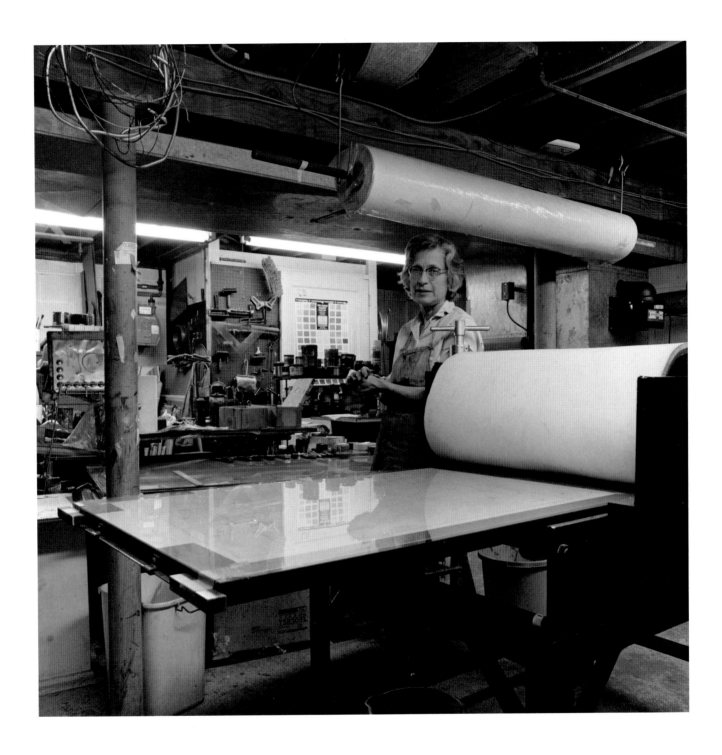

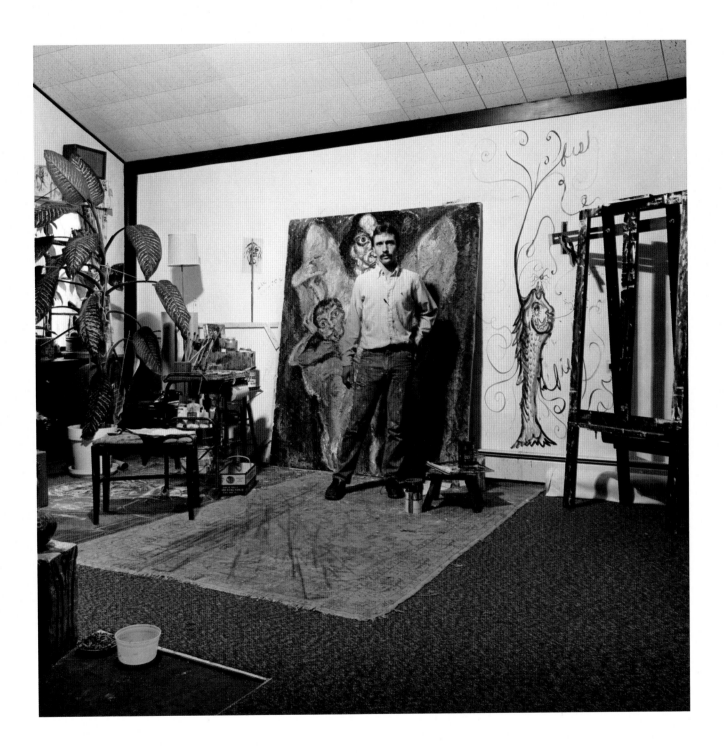

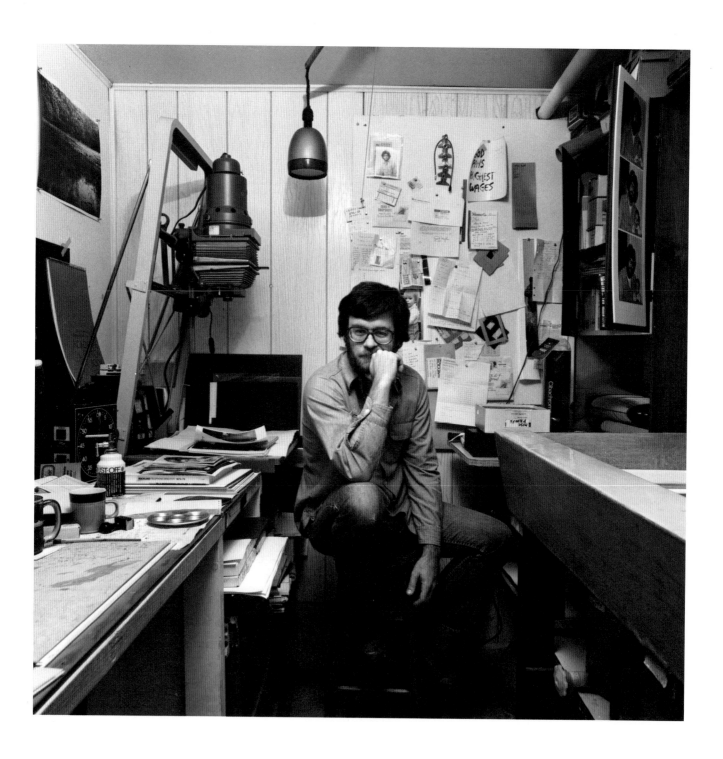

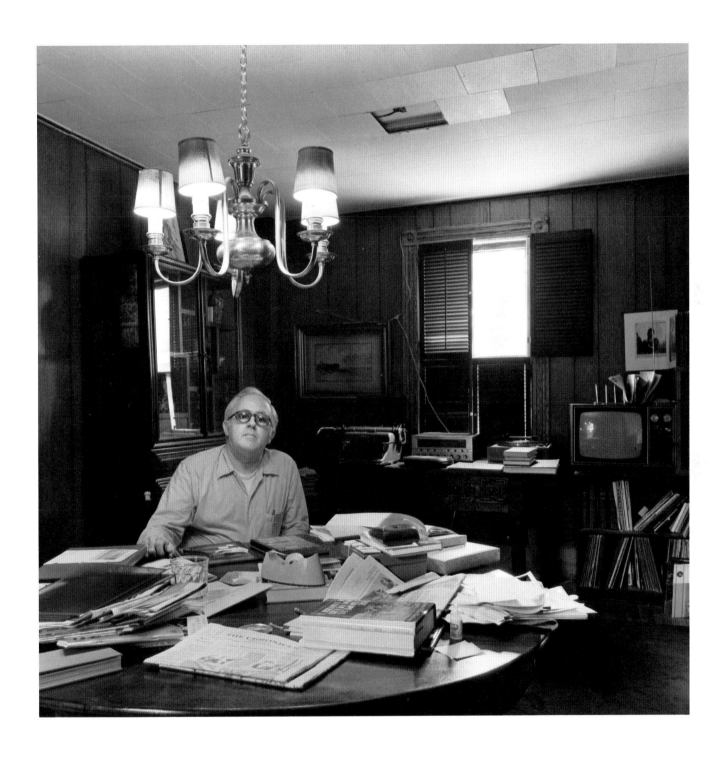

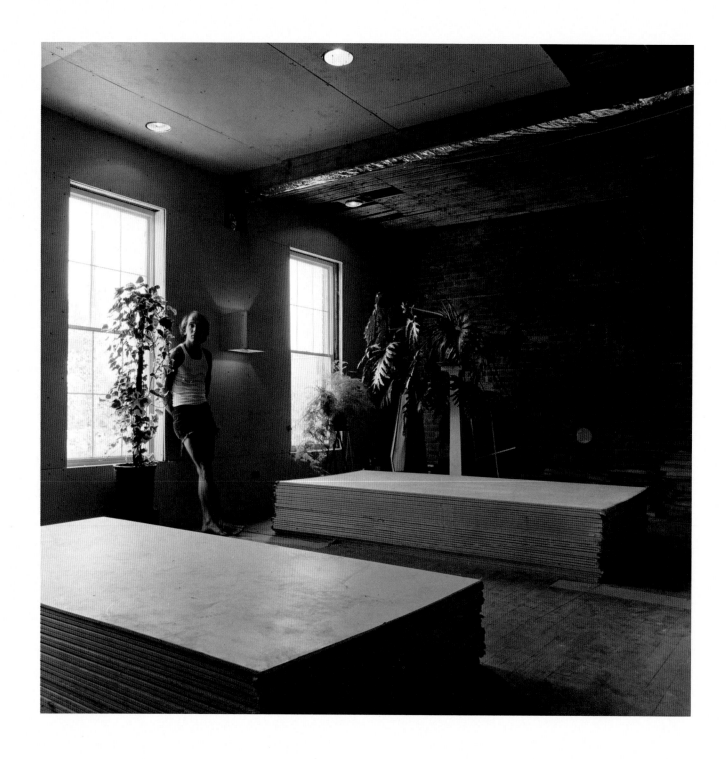

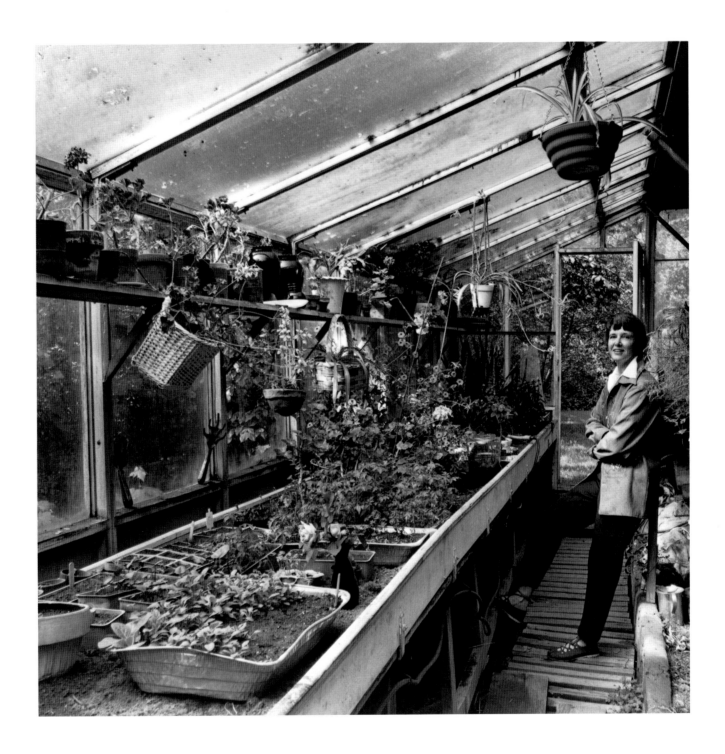

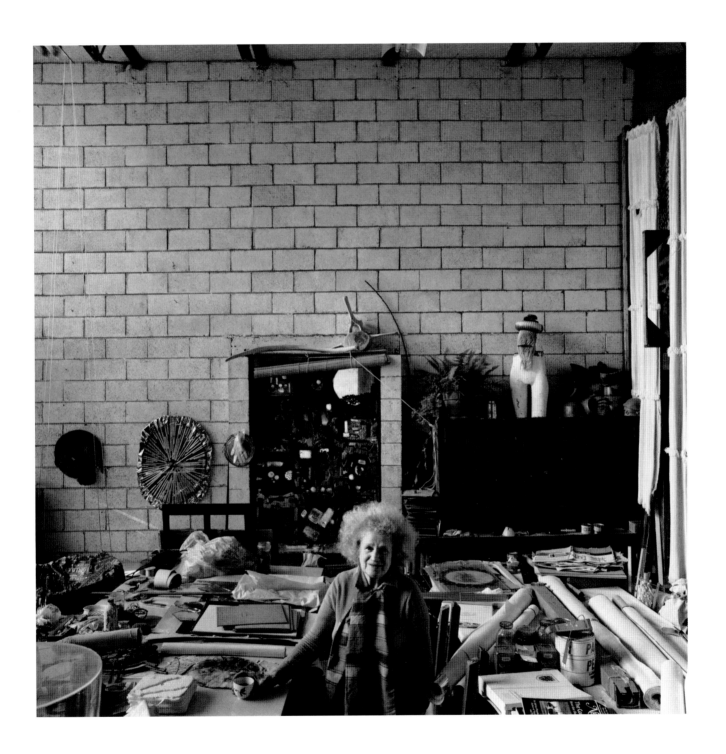

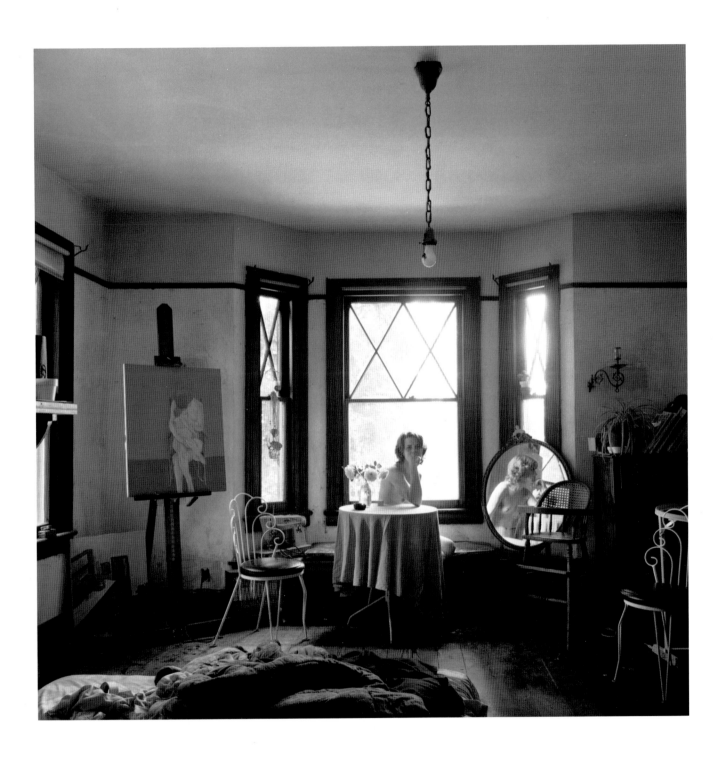

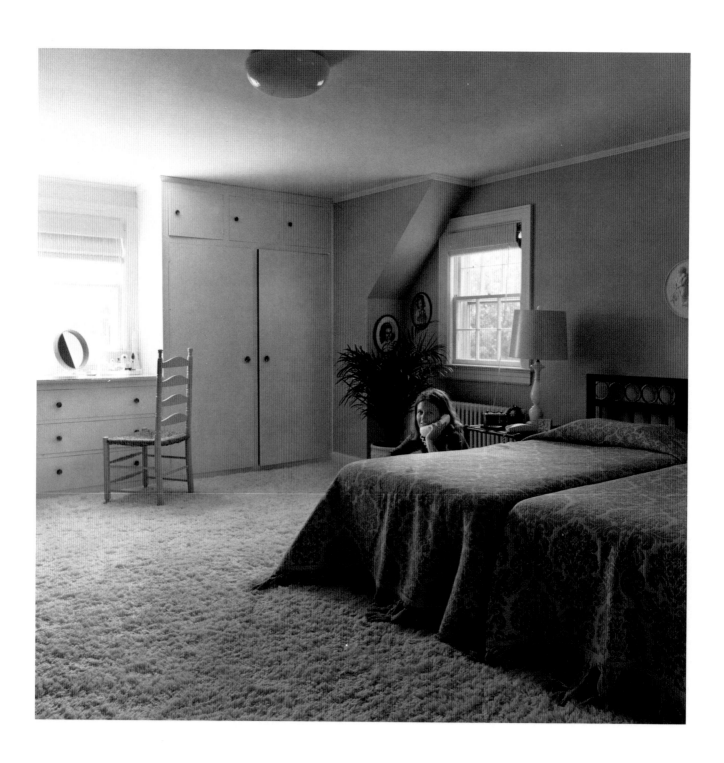

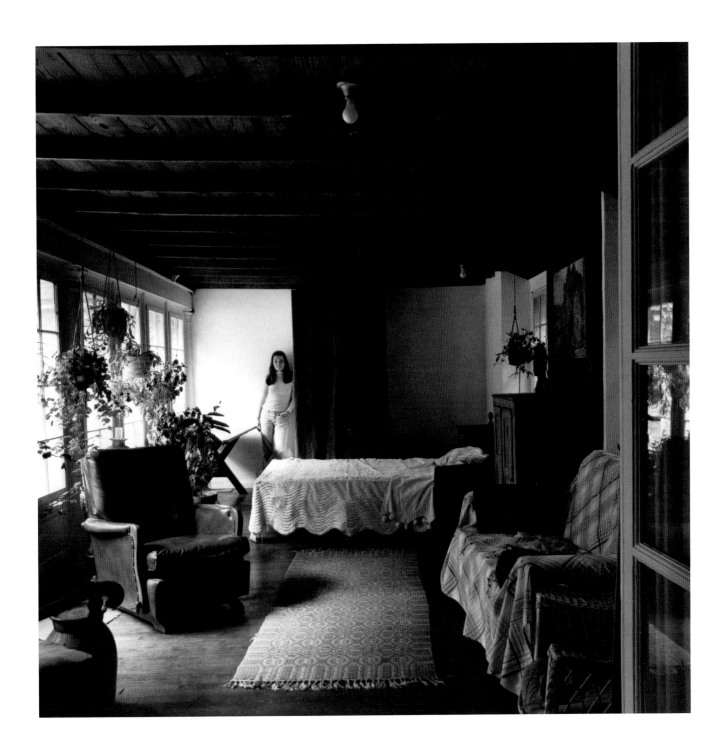

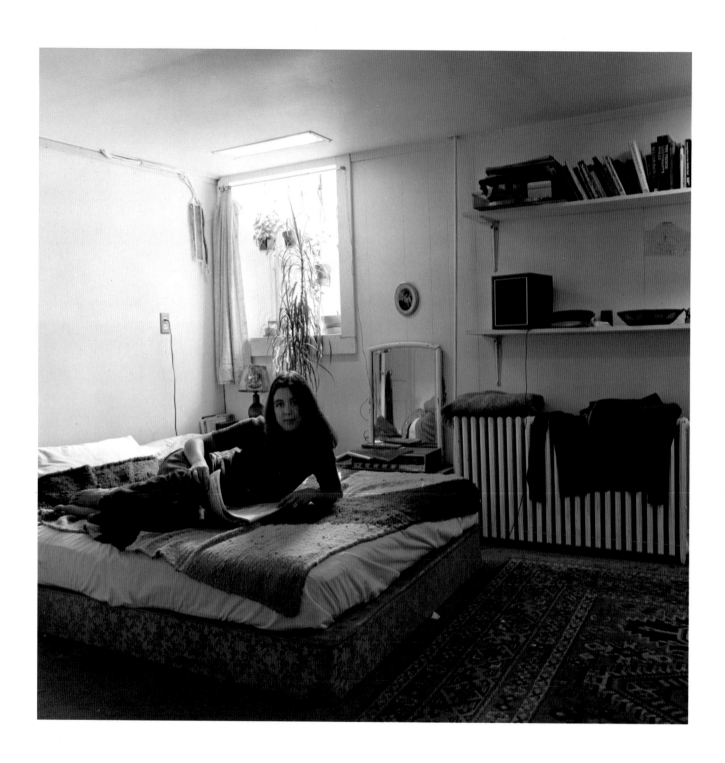

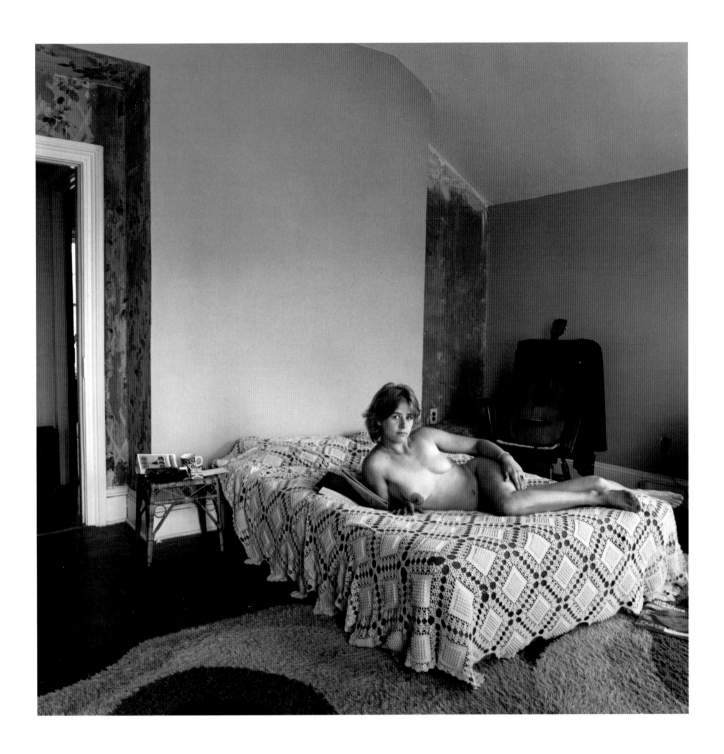

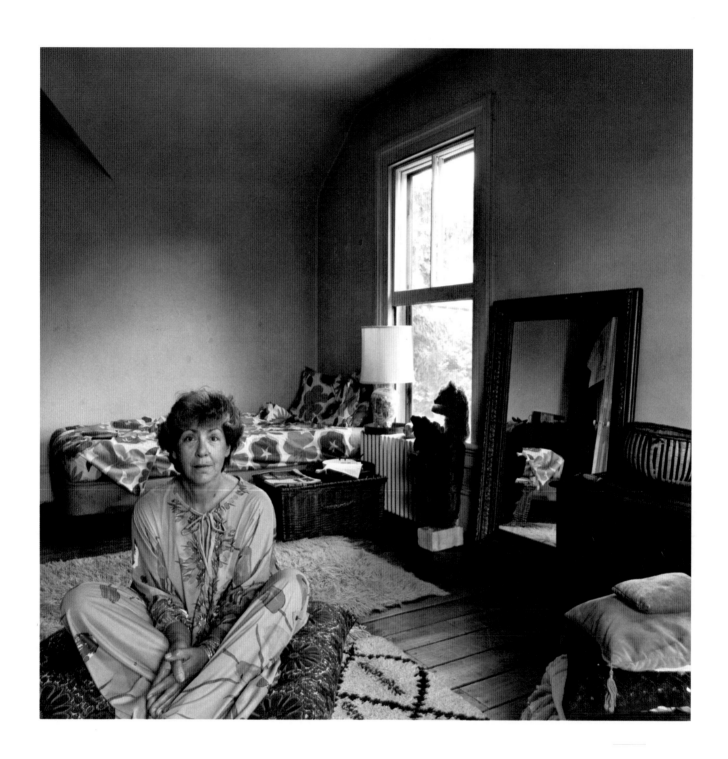

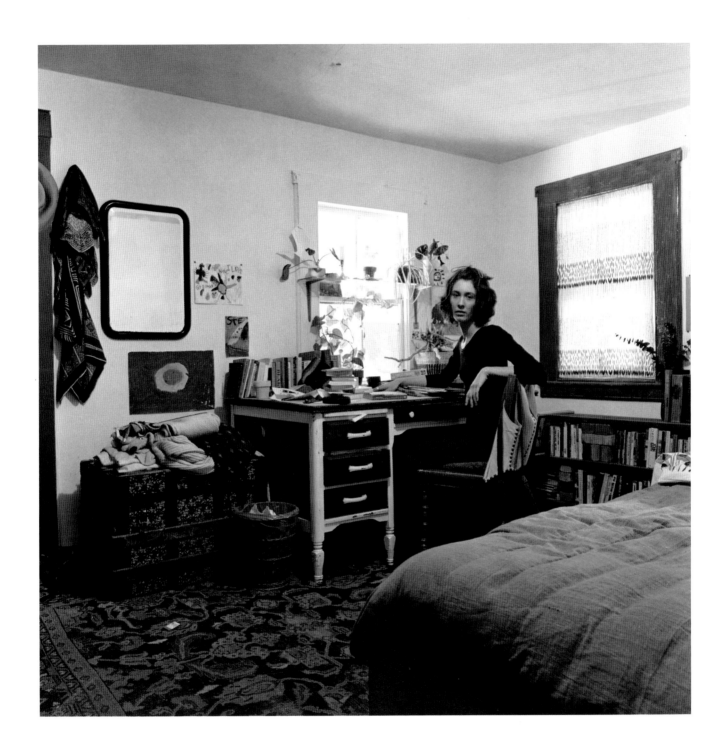

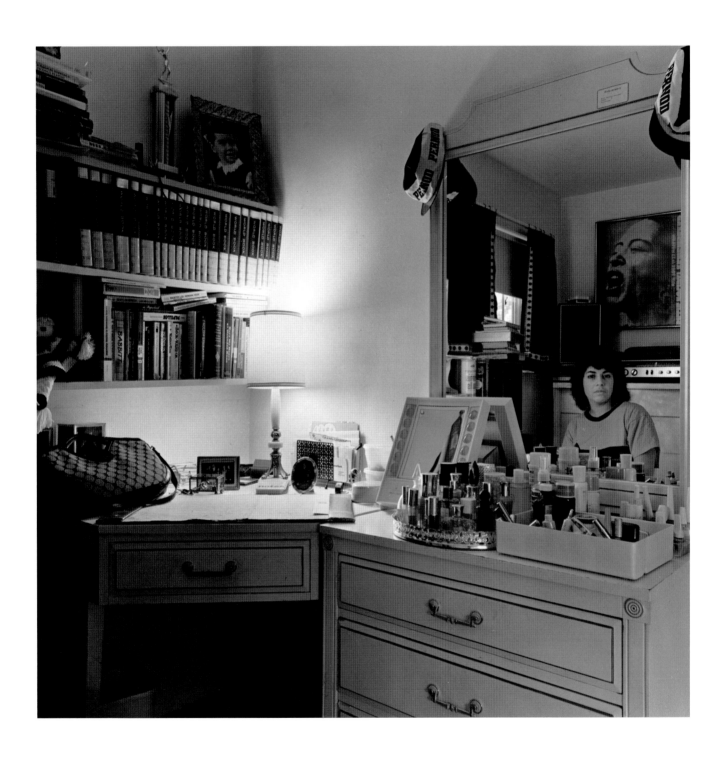

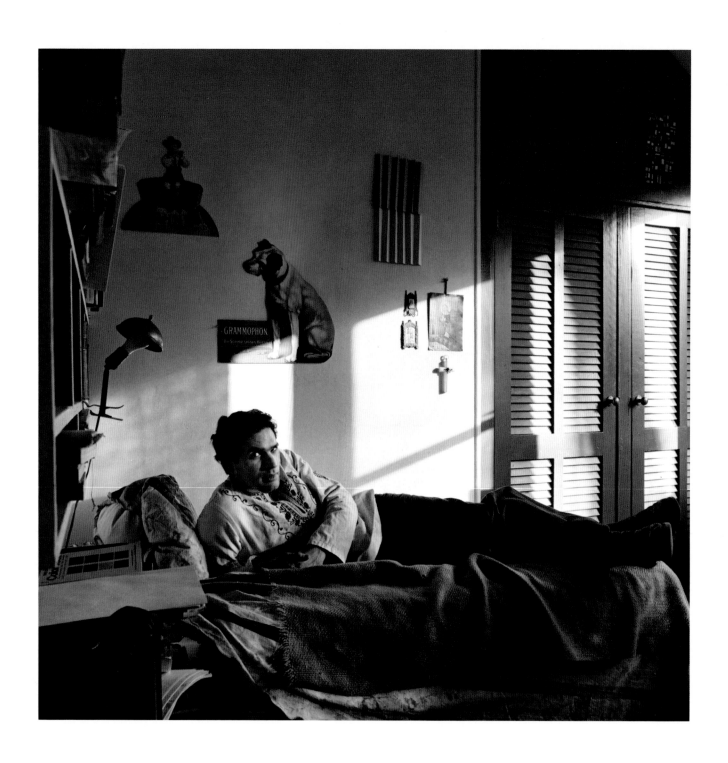

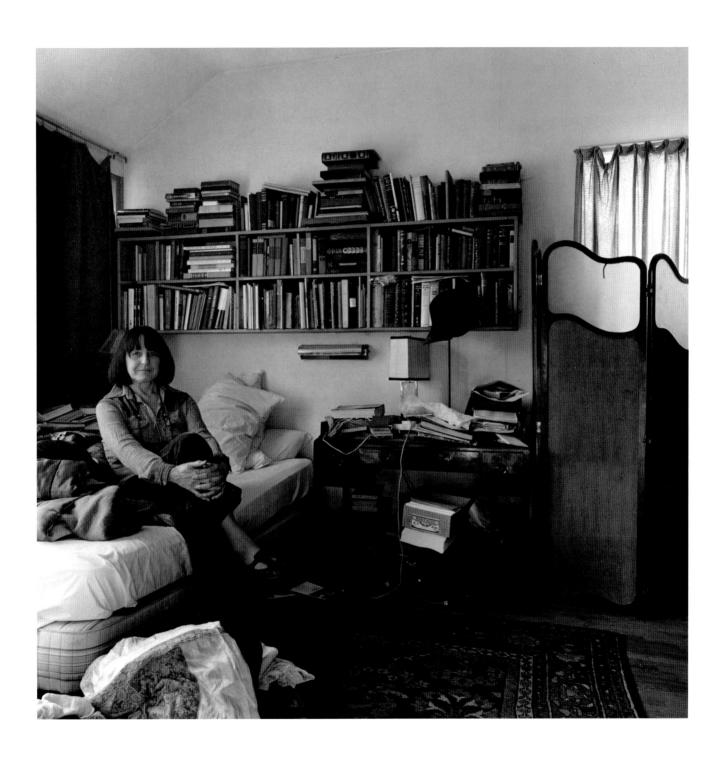

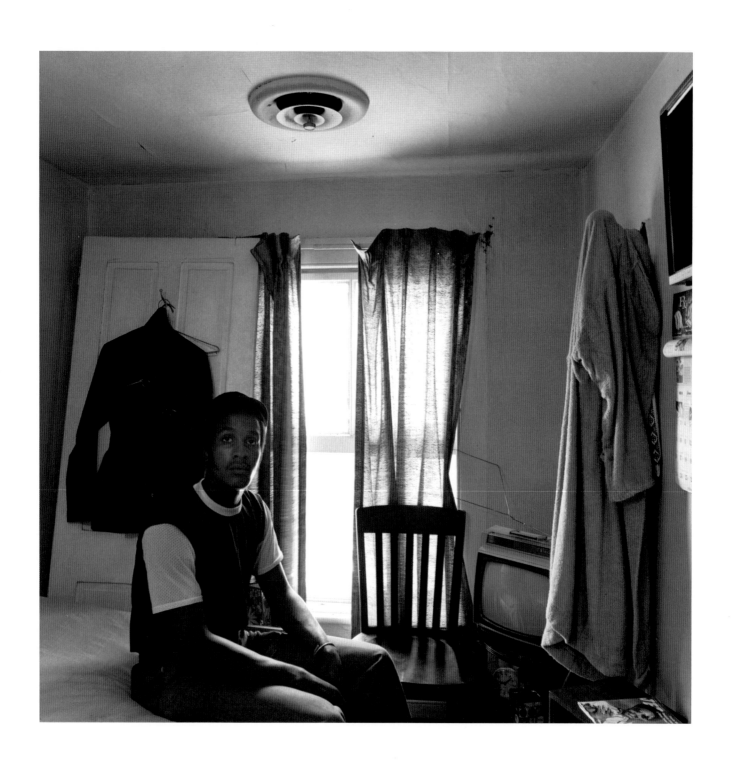

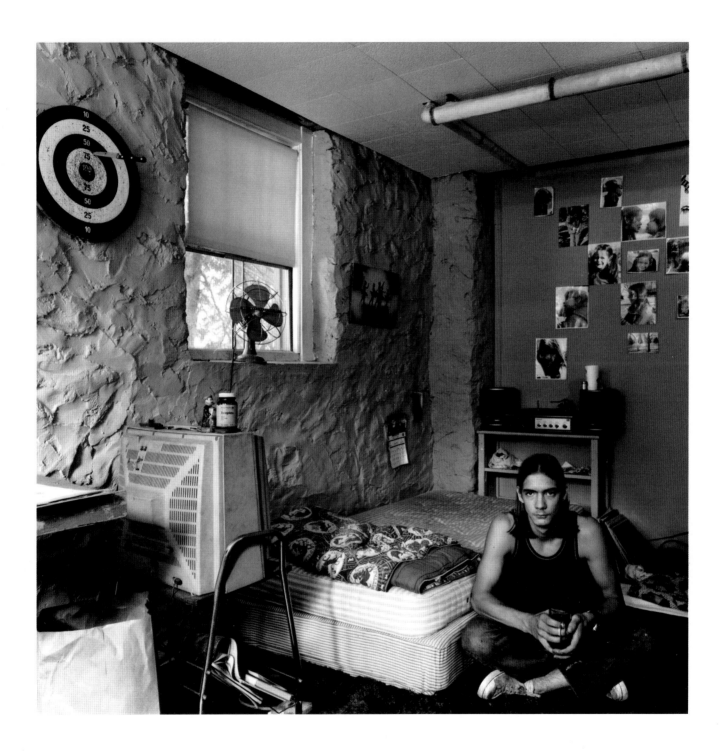

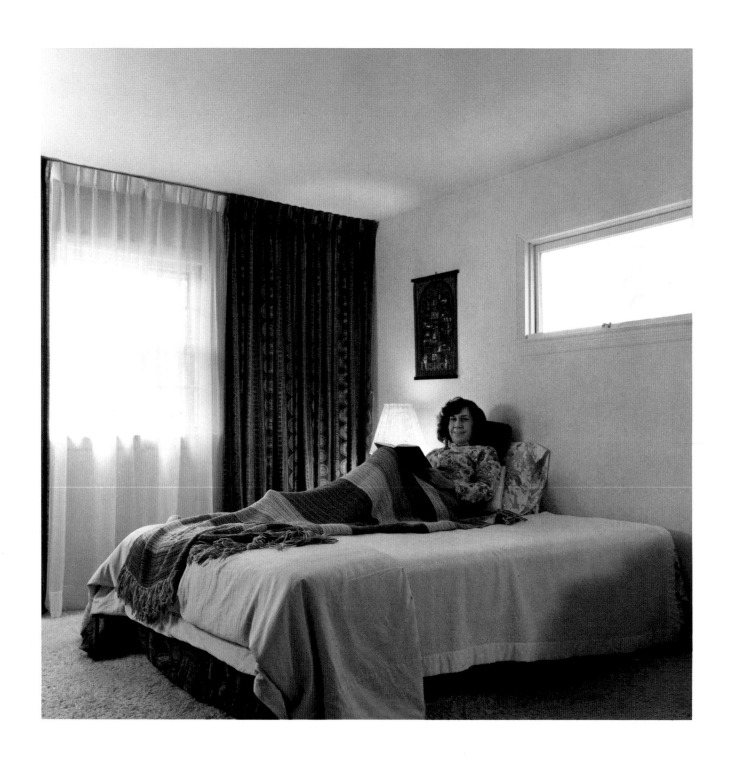

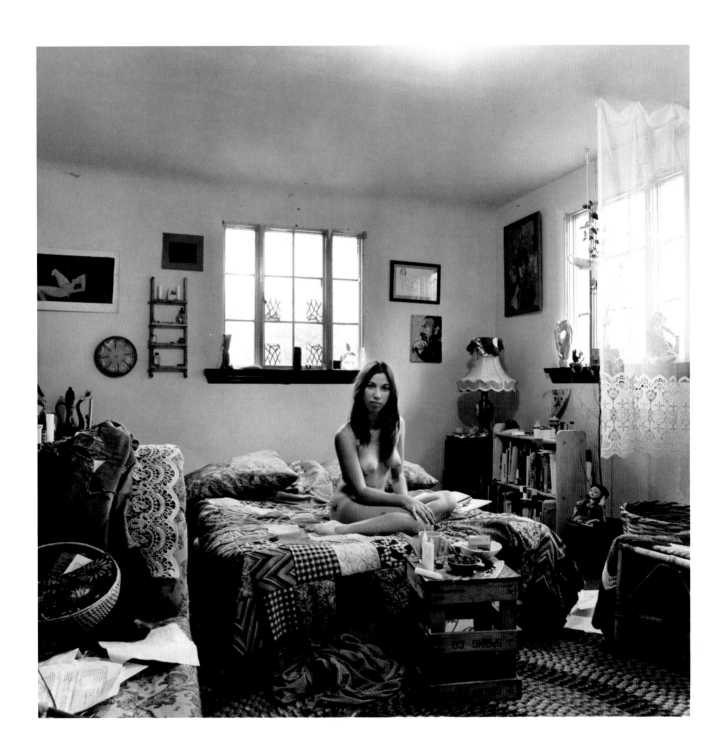

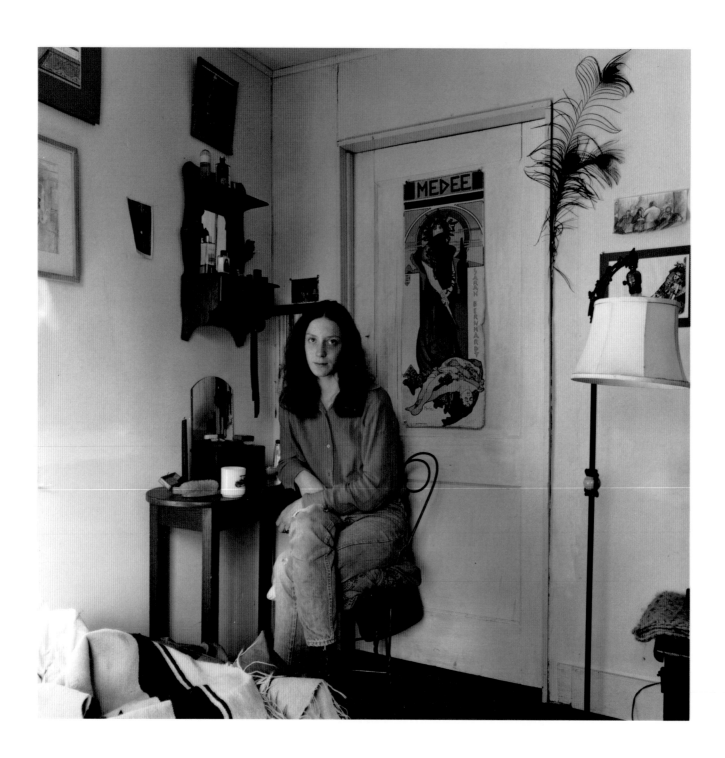

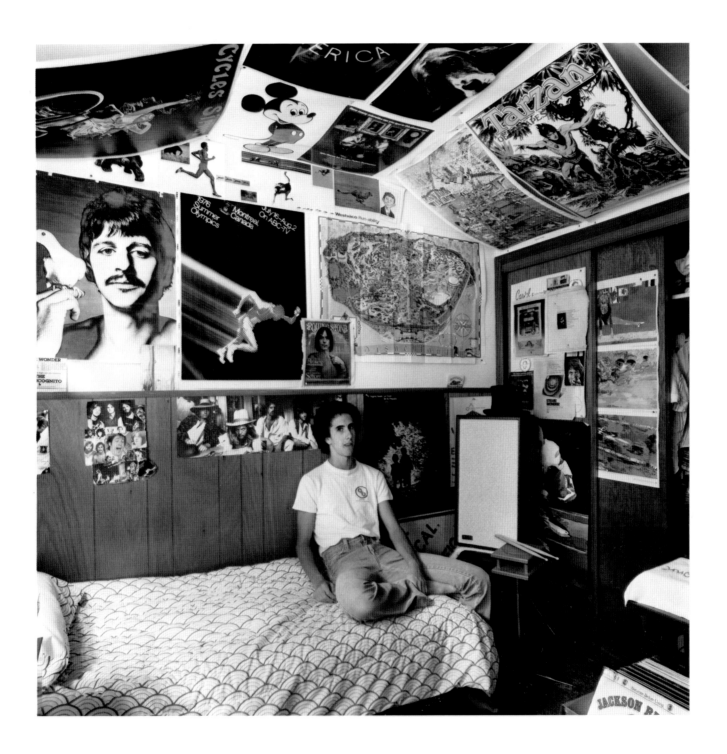

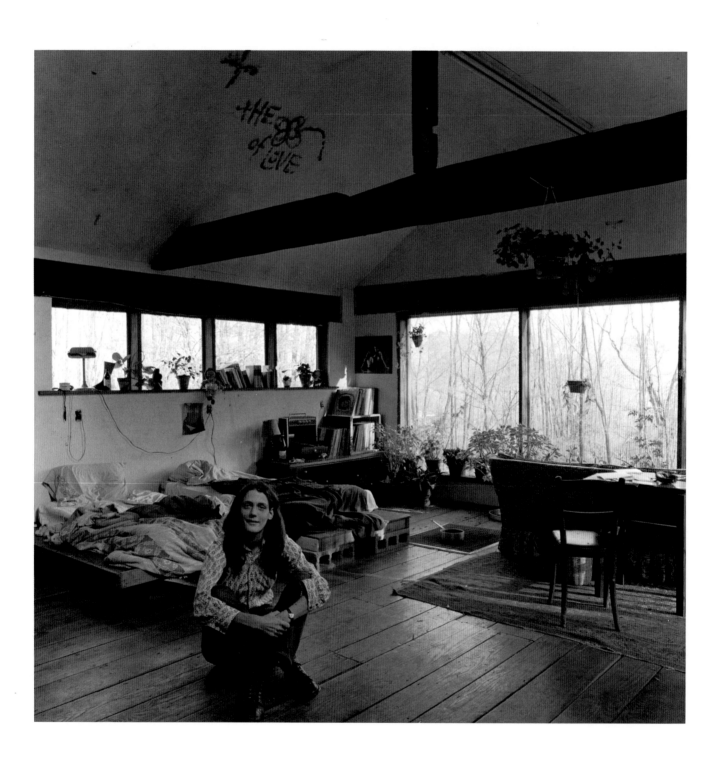

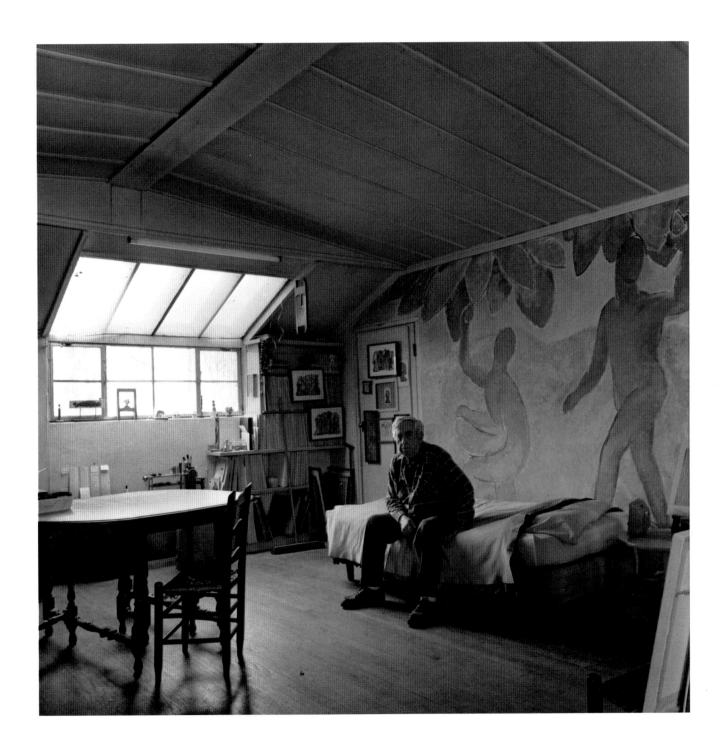

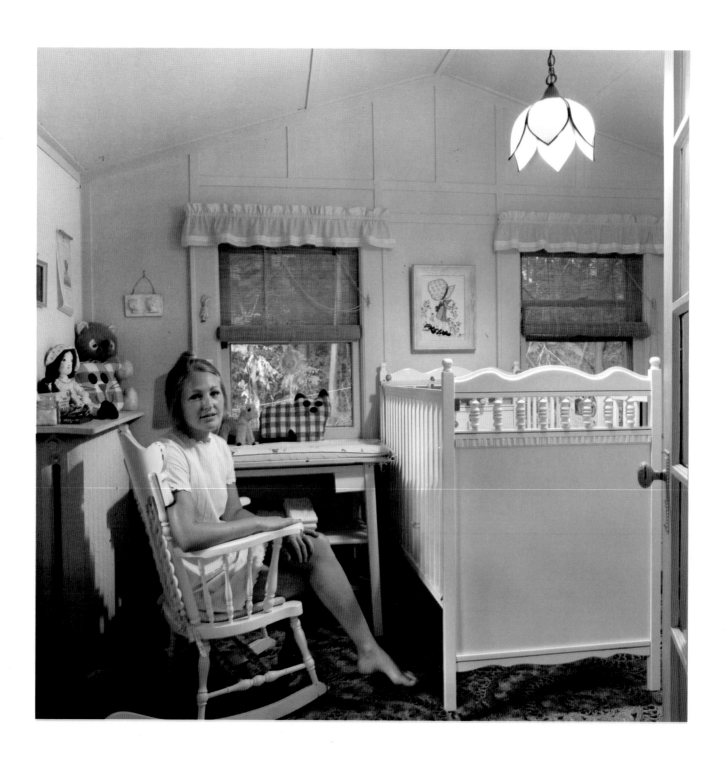

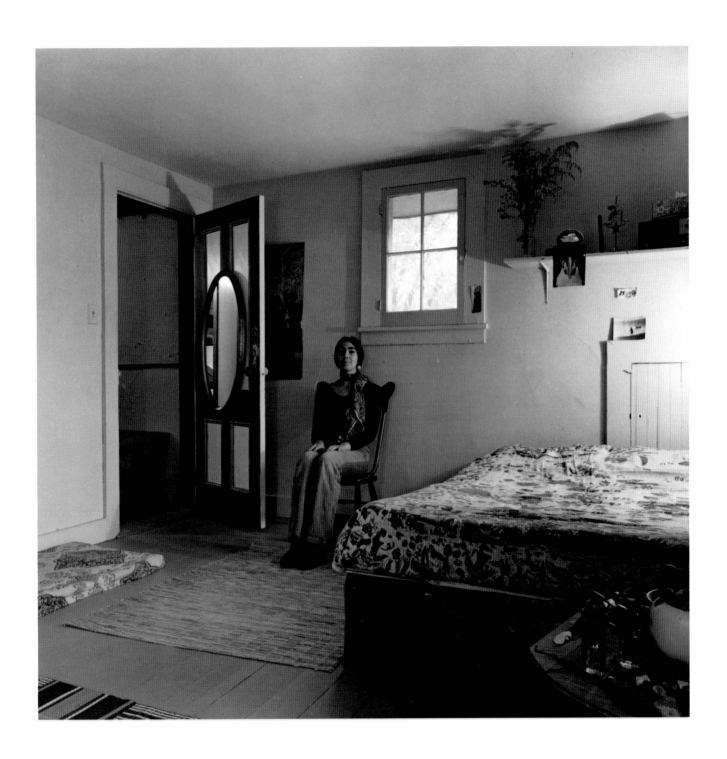

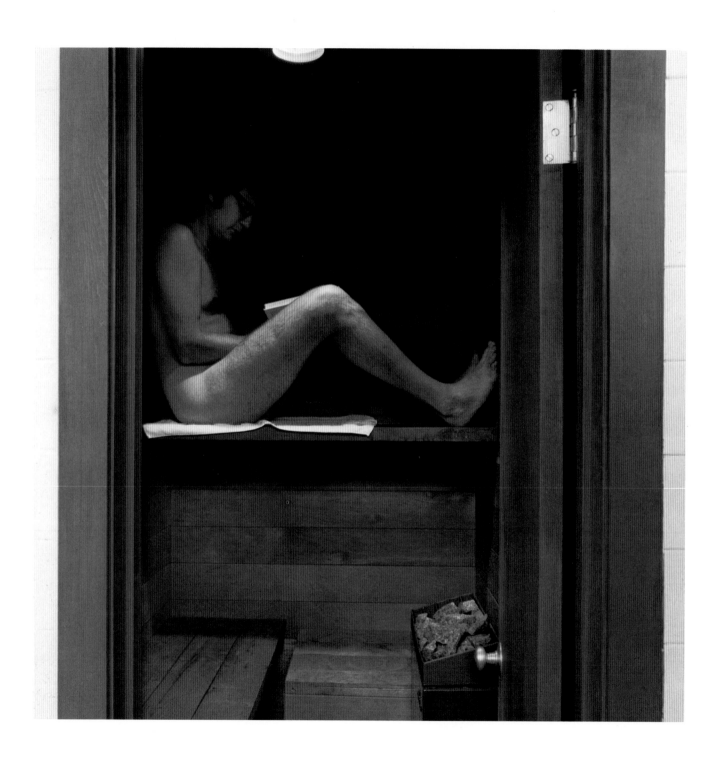

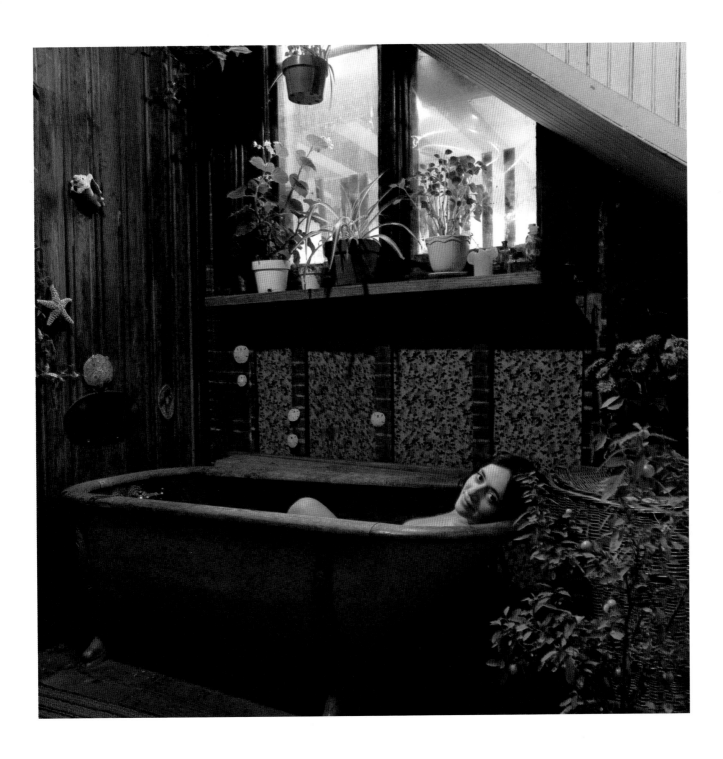

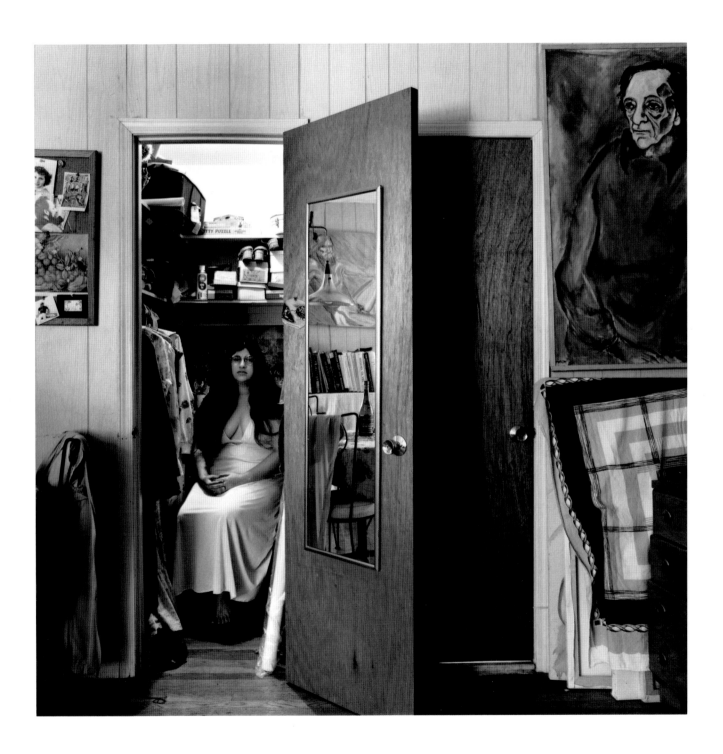